Keys to Painting Better Portraits

THE DIARY

Man may keep his secrets under
lock and key . . . life writes
them on his face for all to see.

—June K. Caddell

Foster Caddell

Keys to Painting Better Portraits

WATSON-GUPTILL PUBLICATIONS/NEW YORK

DEDICATION

The longer my life and career continue, the more I realize how important it is to have some one by your side who shares your problems and successes.

In this life there are four things we all need: some health, some work, some talent and some one. June is that some one—so, once again, this book is dedicated to her.

First published 1982 in New York by Watson-Guptill Publications, a division of Billboard Publications, Inc., 1515 Broadway, New York, N.Y. 10036

Library of Congress Cataloging in Publication Data
Caddell, Foster.
 Keys to painting better portraits.

 Includes index.
 1. Portrait painting—Technique. 2. Portrait drawing—Technique. I. Title.
ND1302.C3 751.45'42 82-1900
ISBN 0-8230-2582-9 AACR2

Manufactured in Japan

First Printing, 1982

ACKNOWLEDGMENTS

In putting this book together, I have been very conscious that although my name is on the cover, without the help of many other people over the years I would not have been able to create the final product you hold in your hands.

I fondly remember Henry Mathus, who saw possibilities in me and paid for my early art lessons; C. Gordon Harris, my first landscape teacher, who inspired me and gave me free lessons in his class each week; and Peter Helck, whom I knew first as a teacher and now as my dear friend and mentor, and who best demonstrated that the lofty principles of fine art could be incorporated into paintings produced as illustrations.

I am also grateful to Don Holden, former editorial director, who launched me in putting my instruction into book form; Marsha Melnick, who took his place and with whom this particular book was conceived and developed; Betty Vera, who edited the manuscript; Jim La Tuga, who designed the final package; Earl Robinson, who did most of the photography and showed great patience in providing me with transparencies of the best possible quality for reproduction; Tony Petri of Mark III Graphics, for additional photography.

My wife, June, has been deeply involved in every aspect of this endeavor, and I could not have managed without her. I also appreciate the wonderful cooperation of the people whose portraits are in this book, many of whom have become good friends because of the experience. And finally, I am grateful to all the serious students who contacted me about how my first books helped them, and who gave me the incentive to spend most of the past year and a half on this new endeavor.

CONTENTS

PREFACE

It is with great personal satisfaction and pleasure that I have written this book, the third in my series of "Keys" to solving painting problems. If a growing group of amateur painters had not found my other books beneficial, undoubtedly this book would not have been realized.

Several years ago, when I first met with the editorial director at Watson-Guptill, I wanted to write a book that would approach the instruction of painting on an all-encompassing basis, demonstrating the universality of painting problems as they apply to *all* painting regardless of subject matter. I have long had the same approach to painting as to music. I believe that if you can play an instrument well, you should be able to play any type of piece on it. Likewise, if you are a good technician and can paint well, you should be able to paint any subject—although it is understandable that you may prefer certain subjects.

Although the director agreed with my philosophy, he suggested that I not try to crowd *War and Peace* into 160 pages. Instead, we decided to do a series of books that would allow me more space in which to discuss the various aspects of painting in greater depth. My first book, *Keys to Successful Landscape Painting*, was followed by *Keys to Successful Color*, in which I expressed my conviction that the study of still life painting gives the student the best technical training for all other phases of painting. In this book I also stress the importance of being able to master simple forms in order to learn to paint the more complicated forms of faces and figures. (Many students insist that while they have trouble with faces, they can paint landscapes and still lifes; it often turns out, however, that they have just as many—but less obvious—problems with less demanding subject matter.)

This book is devoted to helping you to see and understand what is before you. Unless you can see analytically, you are likely to paint what you *think* is the solution rather than what is actually taking place. In portrait painting, for example, students are often afraid to paint flesh

tones dark enough; they fear it will no longer look like flesh. Never underestimate the importance of being able to read the facts that are in front of you. Theoretical knowledge can help sharpen your perception. This is the reason artists study the rules of perspective to learn to see spatial relationships, and study anatomy in order to understand how bones and muscles affect the surface they are painting. Ideally, a good artist combines theoretical knowledge with perspicacity.

To do portraits you must be able to draw well. This doesn't mean, however, that a portrait must be drawn out in complete detail before you begin to paint, as some students believe. On the contrary, I usually sketch out my initial conception very freely, as my beginning demonstrations will show—but I believe that you have to have the ability to be accurate whenever the total process requires it. Studio exercises in painting still life subjects will develop this ability.

If most people had the ability to do all the right things at the right time, they would no longer be students. Most of the time I find that students are too obsessed with trying to get a good likeness when they paint a portrait. I have heard students say, "I don't want to start painting until it is all drawn out well and I have a good likeness." They approach painting a portrait as if it were a map that must be drawn out and colored in! Getting a likeness is not a bad objective, but I find it can prevent a student from making the portrait a good piece of art work. It takes a talented painter to make a good likeness that is also a good painting, and this comes only after many years of training and practice. To some it never comes. I shall discuss this further in the Keys, but here I will simply state that I strongly urge my students to go after a good, solid conception that is well-modeled in terms of color and value. That is a great accomplishment, even if the painting is only an eighty percent likeness.

Too many bad paintings are treasured just because they are likenesses. Many portraits are

like some people's dogs—tolerable only to their owners. A good portrait, however, must please two different types of viewers: those who expect to see a satisfactory likeness, and those who do not know, or particularly care, who the subject is but want a portrait to be a good solid painting and stand on its own. Most portraits in museums are hung because they are good examples of representational painting by the artists who did them; usually we remember their subjects only because of how well they're painted.

A few years ago I painted a portrait of the chief executive officer of a bank and was invited to be guest of honor at the annual meeting, at which the painting was to be unveiled. When I got up to say a few words, I said that I was delighted *they* were pleased with my efforts, but I also had been very conscious, as I was working on the painting, of what fellow artists would think of it as artwork when they came into the bank. They probably would not know or care that it was the exact image of the sitter. (Unfortunately, most people who commission portraits know little of the aesthetics of art and think that the more photographic your painting is the better painter you are!)

Occasionally I find myself in the position of an iconoclast, challenging long-held popular beliefs about painting. Let me give you an example. Have you ever been in an art class when a visitor, wishing to make a knowledgeable-sounding comment, said, "Isn't it interesting how everyone sees the model so differently?" What prompts a statement like this is the fact that the images on canvas look different—but that is because the students are unable to draw and paint accurately. The model may appear a little heavy in one painting, thin in another, and in yet another one have too much space below the nose. Unless there is something wrong with the students' eyes, however, they are all seeing the same model, but from different angles. Please understand, I am talking about a classroom with a group of students, not a situation where several competent painters are working

from the same model. Only in the latter instance would you find truly personal interpretations. Most students just don't have the ability to keep their paintings sufficiently under control to represent the model accurately.

I am often asked what elements are necessary in order to become a successful painter. I have given this question a great deal of consideration and will share my thoughts about it with you as honestly and simply as possible. First, you must be blessed with a certain amount of talent and a reasonably intelligent mind. These are elements one is born with. You can do a great deal to develop them, as you are now doing by reading this book, but how far you can go is governed a great deal by your innate abilities. Second, you must be willing to work hard to develop your talent. Michelangelo is credited with having once said, "If anyone realized how hard I had to work they would not think it quite so miraculous." I tell my students in my summer outdoor-painting classes, "When I can take you out on a hot summer day and have you stand by a pond trying to paint reflections in the water rather than being in there swimming—then there is hope." The third element is to be fortunate enough to have an environment in which you can get to know great art and find a teacher who will help you and make the path easier. Very few of us ever got there on our own. An old saying is "He who is self-taught has had an ignorant teacher." I often think that if I had been born at a different time, or into a different culture, I would have merely carved a slightly better totem pole than the next chap; I would not have done the paintings in this book.

The purpose of this book is to make the road a little easier for you, for the difference between an amateur and a professional is knowledge and experience. *You* will have to do the work, but I can help you to think. Most students tend to make the same kinds of mistakes. I shall do my best to make you aware of them so that you will be able to eliminate them from your own work.

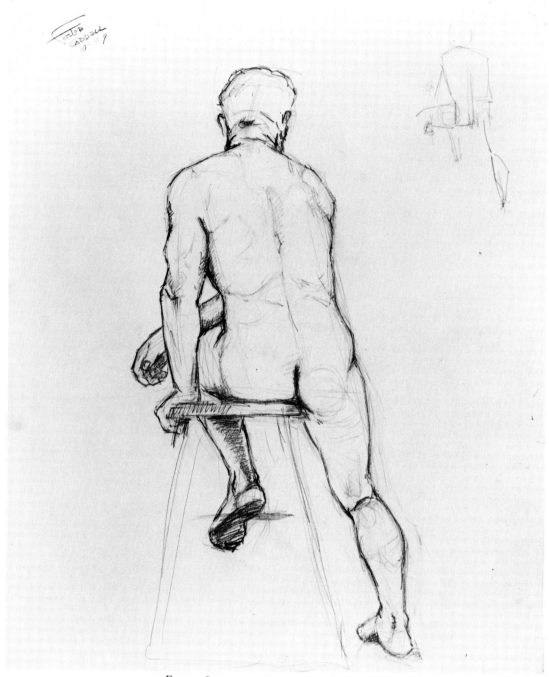

FIGURE STUDY, *pencil on paper, 24" x 18" (61 x 46 cm), Collection of the artist.*

If you aspire to paint portraits, the ability to draw is an absolute necessity. While it is true that some people are born with a greater aptitude for drawing than others, it *is* a skill that one can learn and develop. I have always enjoyed drawing. This is a pencil sketch I made in my first life drawing class, when I was eighteen years old.

Good drawing requires the ability to see relative sizes and shapes. It calls for keen observation, perspicacity, and then, once you have analyzed your subject, the skill to reassemble the shapes and proportions you see in a particular medium.

Let me make an important point, in case you are not already aware of it: you do not learn to draw particular subjects, such as portraits or figures—you learn to *draw*, period. (Studying basic still lifes is the best way for the beginner to learn how to draw.) You must train yourself to draw well, even if you think you can get by without it in your painting. If you try to take shortcuts in a drawing, you are only short-changing yourself, for if you can draw well you can handle any subject.

Some amateurs attend sessions of sketch groups that have no instructor. This can be interesting recreation, but to learn you must have a teacher who constantly gives you strong criticism and points out all your mistakes, until you can either see your errors for yourself or no longer make them.

HOW TO USE THIS BOOK

I hope you will find this book different and more informative than many others on portraiture. I am not trying to make the subject seem simple—because, quite honestly, it isn't. Painting portraits requires a great deal of knowledge and training, and that's what I will try to help you with. I am really trying to teach you how to think.

This book is not intended to give you rules or color formulas that will assure you success if you follow them. Some teachers prefer to teach you cliché formulas for "how to paint blondes," ". . . redheads," and so on. Believe me, I know of no such easy solutions to the difficult problems of painting the human form. Even though I will demonstrate three separate step-by-step procedures for painting a portrait and figure, this is not primarily a "how-to-do-it" book.

I am assuming that you have some painting experience but are running up against problems with the human form that you can't seem to solve by yourself. I have long felt that there should not be any "secrets" in painting, and I want to share my solutions to the painting problems so prevalent among students. In a series of thirty Keys, I will explain why many common problems occur and how to either avoid or correct them in your work. The Keys follow the format I used successfully in my other books; in each Key, I discuss both a good and a bad solution to the same problem.

I realize that many of you will not make mistakes as bad as the ones I often show in "bad" examples. I hope, however, that by shocking you with these obvious extremes, I can help you to see and correct your own mistakes, even if they are only modified versions of the ones shown. The Keys are not limited to demonstrating one problem each. You will find that I sometimes incorporate other problems often encountered at the same time; see if you can find these other mistakes as well. In this way you will be training yourself not only to see them, but also to understand *why* they are mistakes. Eventually you will be able to apply this thought process to your own work, for when you know *why* something is wrong, you usually know how to fix it.

The "good" examples are oil paintings and pastels selected from the many I have made over the years. Each demonstrates the particular point I want to bring out in the Key, but try to study these examples for handling and techniques that space does not permit me to discuss in detail. Needless to say, because I believe in painting directly from nature, all the work shown (with the exception of the posthumous portraits) was done directly from life and not from photographs.

I often repeat statements and ideas in this book, just as I do in my classroom. This book is not designed to be read through in total as you would read a novel; rather, I hope you will learn to use it as a reference book, studying specific passages as you encounter problems with your own work.

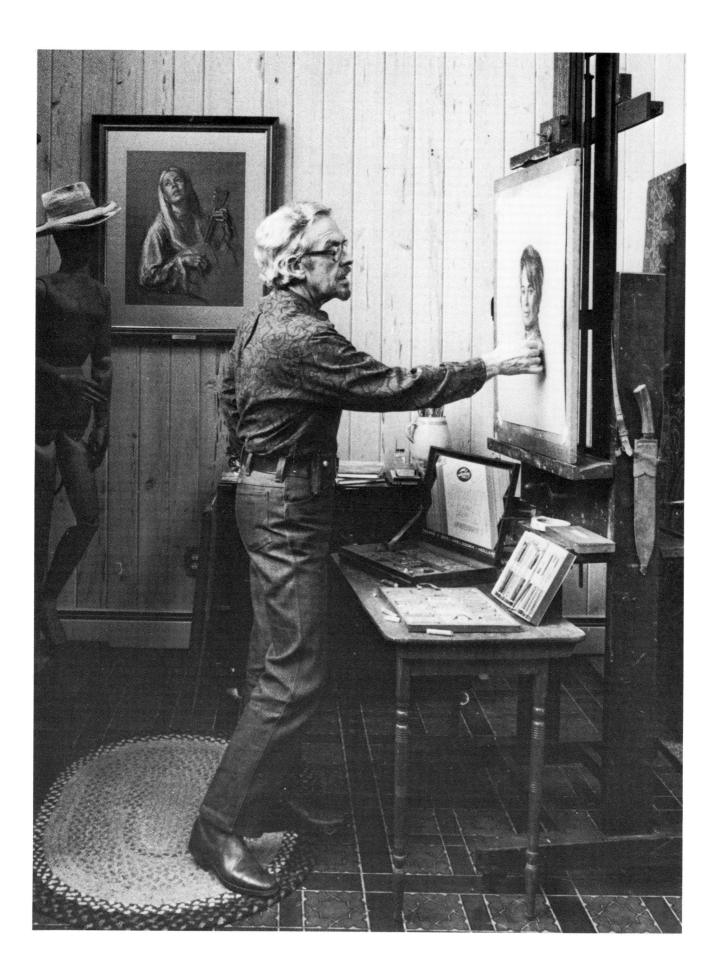

Working Methods

MY STUDIO ENVIRONMENT

Before I get into my discussion of painting, I would like to tell you a little about my studio and working conditions. I might add, philosophically, that most of us have to prove ourselves under less-than-desirable working conditions. So often, ideal accommodations are part of the rewards that come only after we are good enough to afford them.

My studio, which is attached to our home, is a room 22′ x 26′ (6.7 x 7.9 m). It has a cathedral ceiling, and the roof slants from 10′ to 15′ (3 to 4.6 m) on exposed 4″ x 12″ (10 x 30 cm) beams. Most of the north side, which is the 15′ side, consists of two of the largest size Andersen windows (6′ x 10′ [1.8 x 3 m]) which open on either end for ventilation. When I built the studio, I positioned them 6′ (1.8 m) from the floor level because I wanted the light to come in at an angle. The entire window can be covered with a drape that is controllable from either end; this lets me select the amount of light coming into the working area. I supplement the natural lighting with fluorescent lights mounted on the ceiling beams and above and below the windows. They are all on separate switches so I can turn them on selectively. The bay window on the side of the studio where I relax is also equipped with a heavy drape so that when I am working, I can close this and eliminate any trace of a secondary light source.

The walls are finished with pecky cypress, which is not only an aesthetically beautiful surface but also very functional. I can place hanging hooks on it at any height with secure nailing—and if I decide to rearrange the paintings, the nail holes hardly show because of the texture of the wood. The hanging wall is illuminated by spotlights on the ceiling beams; these can be controlled by a rheostat switch for the desired amount of light.

The studio itself does not contain storage racks for canvases and frames; these are in adjacent rooms and in the basement under the studio.

My studio, with its expanse of glass on the high north side, is a most impractical building to heat; it has baseboard convectors (hot water heated by an oil furnace). With the price of oil skyrocketing, and because I live in an area with much wood available, I recently sacrificed part of my hanging wall and installed a wood stove—which keeps this room warm and me solvent!

For a model stand, I purchased a very sturdy old dining room table and cut the legs off so that it stands 16″ (41 cm) off the floor. I solved the problem of mobility by placing it on a braided rug, which permits me to slide it around on the vinyl floor when necessary but eliminates the possibility of accidents that casters might cause.

I am fortunate to have a wonderful old oak easel that is double-sided; both its elevation and tilt are controllable with cranks. In front of the easel I have an old wooden sewing table that I purchased years ago for a couple of dollars. It is sturdy, yet the legs fold up for storage. I use this support for both my pastels and my palette of oil colors. For oil painting I use the large palette that came with the old easel, but I have not held it in years. My left hand always has a rag or paper towel for constantly wiping my brushes as I work.

I have a second large easel which I use for displaying work or for holding a mirror behind me as I work. The mirror serves two purposes. While I am working, my eye and mind often become fatigued and don't pick up mistakes. When I view the painting in reverse through the mirror, it gives me a new perspective on my painting problem, and quite often the mirror will reveal mistakes that I did not see when viewing my painting directly. Often the mirror can be placed in such a way that my model can view the proceedings. This gives the sitter a greater sense of participation and encourages an eagerness to help, resulting in less boredom and fatigue.

While I am discussing models, I want to make a few suggestions that you may find helpful. In the classroom, I maintain a regular time schedule for poses, using a wind-up kitchen timer. I al-

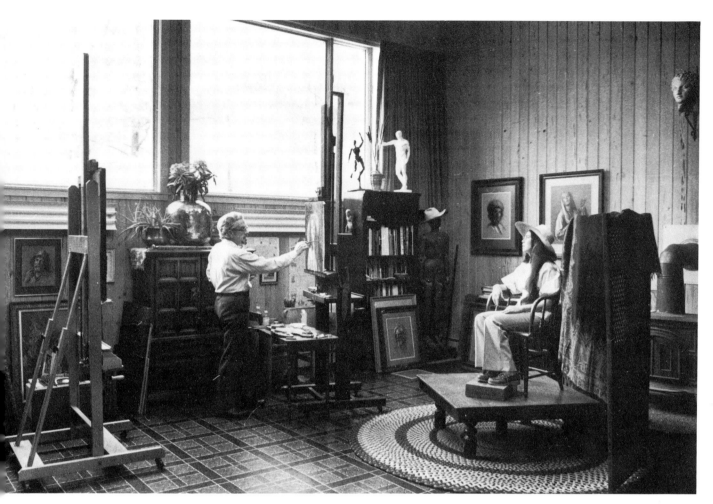

low for 25-minute poses with 5-minute breaks, but this may vary according to the difficulty of the pose. When I am working by myself, I take a more relaxed approach. I usually time the length of the poses according to how relaxed or fatigued the model is. When many people are working from different angles in a classroom, the model must hold the entire pose. When I am working alone, however, this is not always necessary. I try to be as considerate as possible of the person modeling, and when the painting is fairly well along and I am working on the hands or lower body, I often allow the sitter to move his or her head as long as it does not interfere with the rest of the pose. During the rest breaks, I often explain to the model what I am doing and the problems involved; I find that my models usually like to share in the endeavor and feel they are helping me. Remaining in a stationary position is more difficult than it seems, and if students were to try modeling just once they would be much more considerate of their models.

For backdrops, I use a folding Spanish screen over which I can drape any of the differently toned cloths I keep in an old trunk in the studio.

The bookcases you see contain but a few of my numerous reference and biographical books. The walls of my adjoining office also are lined with bookshelves, and there are bookcases throughout our home. I not only write books, I also am a confirmed bibliophile; I started acquiring books years ago, and I find that now many of them are no longer obtainable and are quite rare.

On top of the bookcase is a movable mannequin and another one that shows the entire muscle structure. In the corner is a large wooden mannequin, which is a great help to me in doing posthumous portraits; I shall explain how I use it later on in this book.

There are many ways of setting up a studio. Mine is comfortable and functional for me, and it may be that this glimpse into my studio has given you some ideas that you can adapt to your own work space.

OIL PAINTING MATERIALS

There are so many problems in making a painting that you do not need to add to them by using poor materials. Not enough attention is given to this important part of painting. Some people work under conditions that I find intolerable. Their brushes are poor and stubby, the paint is half dried on their palette, their canvas is not stretched taunt enough—I could go on and on! Therefore, I would like to share my thoughts on this subject.

Brushes. I use a good quality bristle brush and revert to a sable only when the bristle brush is not small enough to paint the details. Most of the time, I use a brush smaller than you might think, but I use it so freely that it looks as though I had used a larger one. I like the long-haired bristle brushes called flats because they carry and release the paint so well. I usually use nos. 1, 2, 3, 4, 6, and 8 flats, as well as a no. 3 round sable for painting details such as the eyes and other areas.

Canvas. I only use stretched canvases; by stretching them myself, I can use different textures that are not usually available in commercially prepared pre-stretched canvases or canvas boards. For portraits I prefer a surface that is not too coarse, yet I want it to have some grain. I personally use linen because it has greater longevity, but I honestly think students can spend their money in better ways—and so I suggest you use a good cotton duck. Sometimes I work on a toned canvas, but mostly I use it just the way it comes—plain white—as I have done in the demonstrations in this book. This is also the approach most students use.

Easel. Get the sturdiest and best easel you can afford. I use the French sketch box easel outdoors, and this can be used indoors also. It folds up into a very small unit for carrying and storage. For indoor work the regulation classroom easel, which has one upright center support, is also good. This folds up into a unit about 6″ (15 cm) deep and stores quite conveniently. The easels that have two upright supports are the sturdiest.

Palette. Because I like to have plenty of room for mixing colors, I use a large 16″ x 20″ (41 x 51 cm) oval palette. However, you need not get such a large one; the regulation 12″ x 16″ (30 x 41 cm) palette is quite adequate. The most important thing about how you use your palette is not its size but how you lay the colors out on it and keep it clean. Some amateurs are in the habit of squeezing out paint anyplace it is convenient, but I could never work like this. I compare an artist's palette to the keyboard of a piano or a typewriter. When I am painting, my hand and brush fly around, mixing colors almost automatically. To do this, I must put them in the same position on the palette all the time. It is also important to clean your palette thoroughly. There should be absolutely *no* paint in the mixing area of the palette that is not fresh and being used. *Never* let any paint remain and harden in this area. Many students have very sloppy working habits, and I often remind them that they don't have to be slobs to be artists.

Another point I want to mention is the consistency of the paint on your palette. I see students working with half-dried paint, trying to remove the "skin" from the globs on their palettes before starting to paint. Now, I am of Scottish ancestry and do not believe in waste, but when the chemical action of oxidation starts to dry the paint on your palette, please have the guts to scrape it off and throw it away! The drying process should be taking place on your canvas, *not* on your palette.

Many students seem obsessed with developing ways of saving the unused paint on their palettes. Some buy special covered palettes, while others keep their palettes in the freezer. I only wish they would put as much thought into *using* the paint as into saving it. Be reconciled to the fact that unless you work every day, you are not going to be able to use up all the paint you squeeze out. The ideal consistency of your paint should be midway between that of heavy cream and soft butter. Unfortunately, the paint manu-

MY BASIC PALETTE OF COLORS

Color Group	Tube Color	Comments
Red	Alizarin crimson	The coldest of reds
	Cadmium red deep	A middle red, neither cool nor warm
	Cadmium red light	The warmest and brightest red
	Flesh	A handy light red that, despite its name, I seldom use in painting flesh
Yellow	Cadmium yellow deep	The warmest yellow
	Cadmium yellow pale	The lightest and coolest yellow, with no red in it
	Naples yellow	A very useful light, creamy yellow
Green	Permanent green light	A very good yellow-green
	Viridian	The coolest green, almost a blue when diluted with white.
Blue	Cerulean blue	The warmest blue
	French ultramarine blue	The deepest and reddest blue
Earth colors	Yellow ochre and raw sienna	Essentially, different values of the same color—used according to the value needed
	Burnt sienna	A wonderful warm earth
	Burnt umber	A deeper brown with less red
Gray	Payne's gray	Actually a combination of blue and black, very handy in portraiture for painting formal business suits

facturers are not fussy enough about this. Some tubes are too hard when you open them and some, too runny. With the correct consistency, you will find you need to use very little, if any, painting medium. That is the way I prefer to work.

Colors. The number of colors you need to use is a very personal decision. Some artists use a very simple basic palette, and others use a vast array of colors, changing their choice of colors according to the subject they are painting. While I am discussing the palette, I want to add that I use the same set of colors and the same layout of my paints regardless of what my subject is. (Just as the piano keyboard remains the same no matter what is played on it.) Naturally, an artist will use more of some colors on certain subjects than on others. For instance, I use a lot more green in landscape painting than in portraiture, but it is always laid out on my palette. There are only three primary colors: red, yellow, and blue. All the rest are derived from these. While we cannot paint with just the basic primaries (it would be

too time-consuming to mix all the secondary colors), we don't really need all the hues that the paint manufacturers produce. (They will produce anything that will sell.) Most of us settle for a selection that is somewhere in the middle. I want every color that is going to help me, but I don't want any that I feel are unnecessary. Using too few colors necessitates too much premixing; using too many requires too little. What I need for my palette is at least one warm and one cool hue of each color. The table on this page lists my regular palette of colors and gives a short description of each one. Unfortunately, paint manufacturers have no consistency in the way they establish colors; a cadmium red light made by one company will often differ from that of another. Many manufacturers produce two or three qualities of paint. You do not need the most expensive grade, but I caution you not to purchase the cheapest, for some of these grades are intended only for tinting house paint.

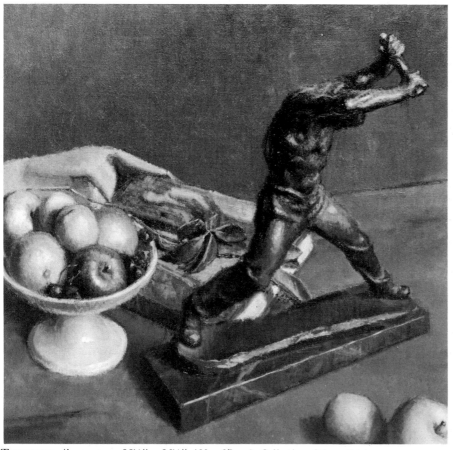

Why is a still life painting in a book on portraiture? Because painting still lifes is the best way that I know of to learn any and all aspects of painting. Still life painting helps you learn to draw well, observe relative values, train your perception of form, mix any color that is before you, and render any texture or surface that you see. One must master this basic vocabulary in order to go on to a more sophisticated study of the human form. Some amateurs do not want to accept this as fact, but take my word for it—it is the truth!

TEXTURES, *oil on canvas, 23½″ x 26½″ (60 x 67 cm), Collection of the artist.*

You will notice I do not have black on my palette. Some artists use it very successfully, but I prefer to mix my own darks. I don't recommend that students use black, for they tend to add it whenever they want to darken a color.

For my white I prefer to use a combination of titanium, zinc, and flake whites; this mixture is sold under various brand names such as Superba and Permalba.

Varnishes. There are two types of varnish, retouch and damar. I had been painting for years before I learned how to use them properly—and the importance of doing so. Retouch varnish is used during the various stages of making the painting to reestablish the wet-strength value of the color. A painting surface has what is known as suction; this means that as the paint dries, or oxidizes, the oil in the pigment is absorbed by dry pigment beneath it or by the canvas itself. As a result, the colors—especially the darker ones—tend to dry lighter in value. By applying retouch varnish, which is a thinner varnish than the final varnish, over the dried paint, you can bring the color and value of the paint back to what it was when it was first applied. The retouch varnish, however, does not act as a separating layer between the dry pigment and the next application of paint. The paint on the canvas, which may be several days old, will look as though you had just stopped work, and it also will be compatible with the wet paint you are about to apply. Some artists do not believe in using retouch varnish, but I have had good results with it during the years I have used it, and I feel it has everything in its favor.

The final varnish, damar, should not be used until a painting has dried completely, which could take from six months to a year, depending upon how thickly the paint was applied. I think of the final varnish as a protective "storm window" over the painting. It keeps the dust, airborne grime, and even cigarette smoke away from the actual painted surface. Damar is a soft resin varnish which is removed in the process of cleaning and restoring a painting. All the dirt and grime is removed with it, leaving the surface of the painting itself as fresh as the day it was completed. The painting is then resealed with a new application of damar varnish.

OIL PAINTING PROCEDURES

There are many ways of approaching oil paintings, and I cannot say that any of them is entirely right or wrong. Eventually you have to find the method that suits your ability and temperament. I used to be a very rapid painter, but over the years I have changed to a more controlled, methodical way of building up to the final effect. This is the way I teach now, as I feel this approach helps an artist to keep a painting entirely under control. The last thing in the world you want is for the painting to control you. One of the most important benefits of this approach is that it enables a student to catch mistakes when they are easiest to correct. If a correction requires a major change in design or composition, this can be done before a great deal of time and work has been put into developing the painting. Human nature being what it is, students often decide it isn't worth the effort to make a correction that means wiping out a great deal of hard work. In this way, however, they keep perpetuating their mistakes.

As a rule, students start painting the final stages of their paintings much too early. Often they try to paint details such as facial features before they have worked out all the big, important concepts. One of the most important points I teach to my students is that every stroke you put on a painting either helps it or hurts it. Often I ask a student why he or she has painted an area a certain way, only to be told, "Oh, I'm just getting *something* on the canvas!" Believe me, "something" is *not* what you want. Every stroke, every passage, must be carefully thought out and calculated to contribute to the total painting. In the next few pages, I am going to take you through my oil painting procedure step by step. I shall explain my thinking in each step of the procedure, and you will see just how the end result comes about.

Oil Demonstration 1

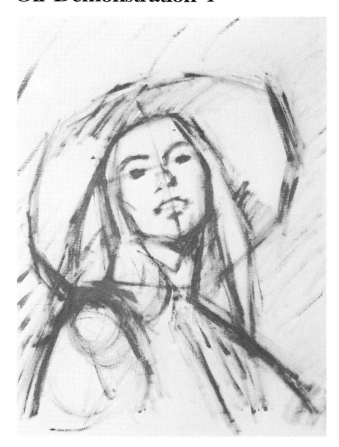

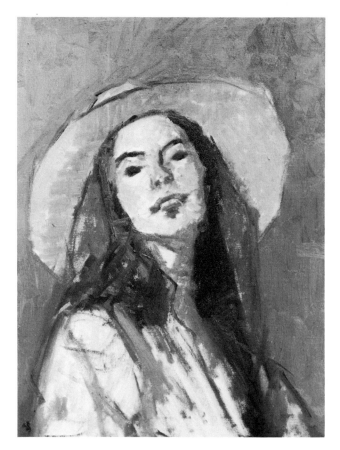

1. DESIGNING THE CANVAS. As I start the painting, do not be fooled by the casual appearance of my sketch. This is actually the most important part of making the painting. Many paintings are ruined during the first half hour because students do not give enough consideration to this important step. In their eagerness to get into "painting the person," they do not put enough thought into designing the canvas. Where is the head to be placed? How large is it? What about the space around it? This is the time to consider these things; at this stage it is very easy to change a charcoal line.

When I stress the importance of good drawing, do not confuse it with *detailed* drawing. At this step, *good* drawing is design and proportion. The detail is added toward the end, as you will see later.

I start off with soft vine charcoal, which can be wiped off readily with a rag if I decide on a change. When I feel reasonably sure I am on the right track, I dust down the charcoal and re-establish the line with a light earth color—yellow ochre. I use a light color purposely so that if I change my mind, I can indicate a change with a darker earth color, such as burnt sienna, that will show up clearly over the first sketch. Corrections are not a major problem at this stage because I haven't yet started to paint.

2. ESTABLISHING THE VALUE RANGE. There are three basic elements used in the construction of a painting: line, value, and color. At this point, the line, or drawing, stage should be completed so that the other two, value and color, can be taken up simultaneously. Students often complain that they don't know what "color" to mix when they really should be focusing their attention on *values* of their colors—which, in many respects, are more important than color. At this stage, most amateurs make the common mistake of starting to paint the light areas first; this happens because many times these are the most interesting and attractive areas. It is almost impossible, however, to establish the correct value of a light area on a white canvas because there are no other values with which to compare it.

You should realize that the most important problem I have now is not painting the attractive young lady in front of me but covering my canvas with all the graduated values that just happen to be her. To do this thoughtfully, I practice what I call comparative analysis: that is, I make sure that every value is accurately determined and painted in relation to the lightest light and darkest dark of the entire subject, including the background. The bare canvas represents the lightest light possible, and so I must begin by painting the darkest darks—in this case the model's hair—and gradually placing colors and values in each area, working through the middle values, and last of all, painting the lights.

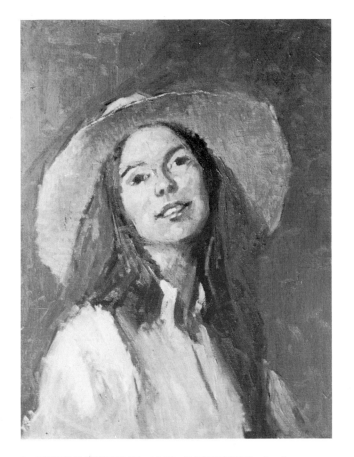

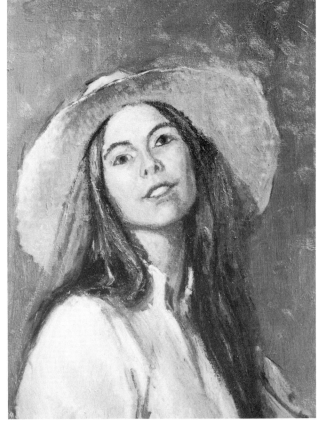

3. OVERPAINTING AND REFINING. I often compare my way of making a painting to constructing a building because it takes shape slowly, with the large masses established first. Now, with the painting roughed in and most of the bare white canvas eliminated, I will start a more refined stage of overpainting. Usually, I allow several days between these stages of the painting so that the underpaint has time to dry before I start repainting on top of it. If I have to work on a faster schedule and paint every day, as I do in workshops, I use a dryer to speed up the drying process.

Now I work on the yellow straw hat, finding as many beautiful colors as I can within it. Next, I rework the face, painting the subtle hues I see in the flesh. I do not believe in formulas for flesh color, and so I am not going to give you any. In order to paint portraits, you must be able to mix *any* color that you see before you, including the many variations of flesh tones. If you observe the colors in a face and mix them as accurately as possible, you will not need formulas to mix them.

4. PULLING IT ALL TOGETHER. In this step I give the blouse more attention while keeping it subordinate to the face, and I work on the red scarf. Notice how I put the right side of the scarf in shadow to avoid repeating the same color I used on the left. I also arrange the hair differently on each side—again, to avoid repetition. Long hair like this could be quite monotonous if it hung down in exactly the same way on both sides. I purposely arranged the hair on the left in a graceful loop that flows back over the shoulder.

At this point, I usually repaint the background. Even though I try to make it the correct value and color at the beginning, when my painting is fairly well along I usually feel that I can make more accurate decisions about the background. Many times, when I suggest my students do this, they reply incredulously, "Repaint the background?!" Actually, with a painting of this size, it doesn't take that long—actually, I have often done it on a 30″ x 40″ (76 x 102 cm) canvas.

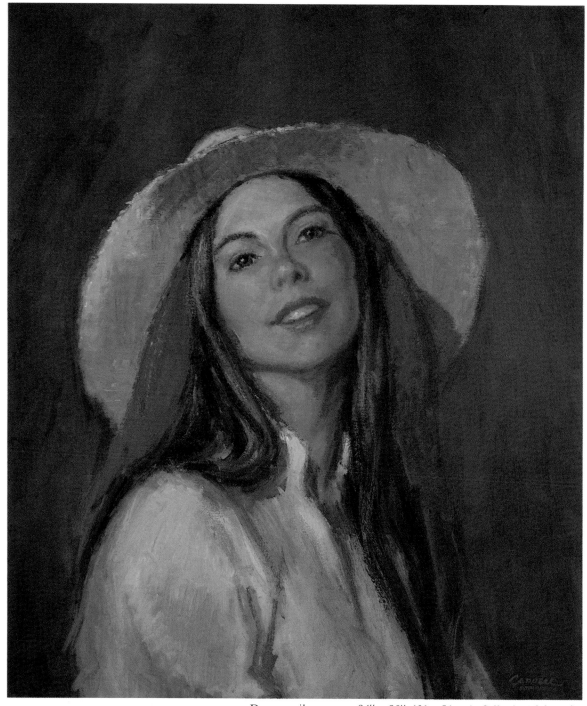

DOTTIE, *oil on canvas, 24″ x 20″ (61 x 51 cm), Collection of the artist.*

5. THE FINAL ADJUSTMENTS. This is the stage where I resolve the details and come up with a final solution for unifying the overall painting. Many different stages of refinement take place now. The features are refined more than the other areas, for I feel this is the most important part of the subject. I use a small sable brush for this, but I brush on the color in a way that does not look labored or tight. I paint the hat more impressionistically so that the very way in which I apply the brush strokes suggests woven straw without describing it in detail. In the hair and the red scarf, I drag color over color, letting the rough texture of the underpainting contribute to the final effect.

Finally, I try to achieve a color harmony that will unify the entire work. See how the muted purple of the background is repeated in the blouse, the hat, the hair, the red scarf—and even in the shadow areas of the face.

In the Keys, I shall go into more detail about my painting procedures, but this demonstration should have shown you the basic mechanics of how I put a painting together.

Oil Demonstration 2

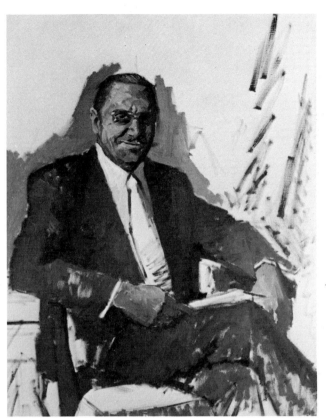

1. DESIGNING THE CANVAS. When doing a portrait that includes more of the figure, amateurs usually start by drawing the head and then continue downward, adding the body afterward. Considerations such as how close the hands come to the edge of the canvas and where the bottom of the frame cuts the figure are often determined by chance. The opposite should be true. How the entire figure fits into the canvas is of the *utmost* importance, and the figure should be roughed in freely but thoughtfully. Only when the figure has been resolved should any attention be given to subdividing the mass that happens to be the face. Once again, I want to remind you that the initial sketch is one of the most critical stages of making a painting. Do not let my seemingly rough approach to the drawing fool you. I have given a great deal of consideration to the entire composition, for the decisions I make now will affect the finished painting. I work in charcoal until I am reasonably sure I am on the right track. Then I dust it down with a rag and reconstruct the entire drawing with a light earth color, in this case yellow ochre, as you see here. Remember that this is the stage when changes are easy to make. Always be willing to try moving and reconstructing any section if you feel it will improve the composition.

2. ESTABLISHING THE VALUE RANGE. The previous step was done in a *light* earth color, for a definite reason. I keep hammering away at the idea of making corrections at the easiest, most correctable stage of the painting. At this point, if I feel something could be changed to improve the painting, I take a darker color, such as burnt umber, and make my correction right on top of the previous drawing. I do this quite often.

After the overall drawing and design has been settled, my next problem is to get the canvas covered with a rough approximation of the correct colors and values. At this stage, I still do not worry about the painting looking like the particular person; I am just gathering on my canvas all the colors and values that will eventually become the sitter.

The important point I should make here is that I do *not* put my light values on first because I have nothing against which to compare them. Instead, I place my darkest darks, letting the bare canvas serve as my lightest values, and I judge all the rest of my values in relation to these two extremes. You can see how freely I apply the paint at this step. I do some modeling of form but give no thought to detail as yet.

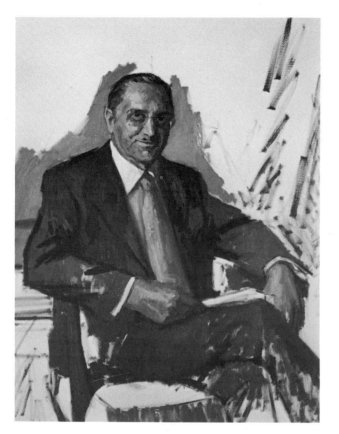

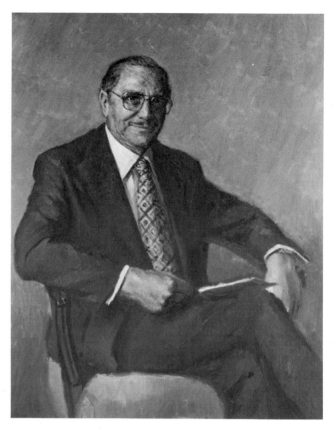

3. OVERPAINTING AND REFINING. When I do a commissioned portrait such as this one, my subject usually sits once a week. This allows enough time for the underpainting to dry between working sessions. Because I approach the work with freedom and spontaneity, there are often thick ridges of paint left here and there that would interfere with the refining process that comes later. By scraping these down lightly with a painting knife after the pigment is dry, I remove the ridges while leaving all the lovely application of color. Then, before the next sitting, I use retouch varnish to re-establish the original "wet-strength" of my color so it will be more compatible with the new application of color. It isn't necessary for the varnish to have dried thoroughly before reworking; I paint right into it within a few minutes.

I rough in enough of the adjacent background so that I am not painting the head and shoulders against the bare white canvas. Now I give more thought and attention to the face and hands. By applying the correct color and value to smaller areas, I am achieving more definition and three-dimensional modeling. I am also starting to get the suit underway. In different sittings, the folds will not always behave exactly the same way, but they will be somewhat consistent in direction because of the strain put on the cloth by the position of the body underneath. You should begin to study these aspects of portraiture because your end solution is to describe the way *typical* folds fall rather than a particular fold that occurs at any one sitting.

4. PULLING IT ALL TOGETHER. Now I cover the background area completely. Many times I will have covered this area before getting to this stage of the painting, but I usually put the background in knowing that when the painting is almost complete, I will repaint it so that it will best complement the figure. I also rough in the chair at this stage, and now that the entire canvas is covered, I can judge color and values against one another more accurately. At this point, all my colors and values should be at least eighty-five percent correct. In fact, they should be as close as I can possibly get them, and as I proceed with the refinement, I will incorporate the remainder of the value and color adjustments I feel are necessary to bring the painting into the most perfect balance I can achieve.

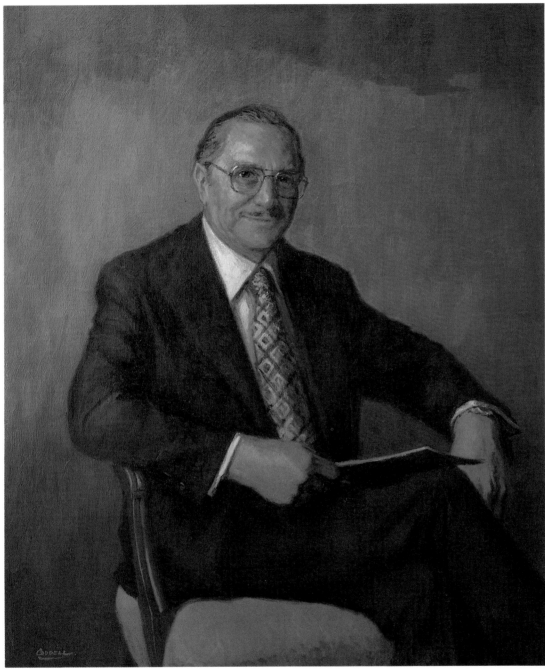

Mr. C. Joseph Scola, *oil on canvas, 36" x 30" (91 x 76 cm), Collection of Mrs. C. Joseph Scola.*

5. THE FINAL ADJUSTMENTS. Now I start the most critical phase of refinement, making any final adjustments necessary to bring the color and value relationships to the best resolution possible. The paint strokes get smaller as I refine the face and hands. Notice how the strategic placement of the hand on the right brings out the dark values of the paper and the knee. I leave alone the areas of the underpainting that are correct, making careful adjustments only to areas that need them. Notice that I make all these refinements without my painting becoming harsh, slick, or "edgy." I am selective about which areas receive more or less refinement. For instance, I leave the pattern in the tie loosely rendered, for I do not want it

to stand out too much. The suit also remains softly suggested. At this point, I refine the handling of the chair so that the arms look like varnished wood and the cushion resembles cloth. I completely repaint the background, bringing the value relationship closer to that of the figure in some areas and accentuating the contrast in others. There are no absolute rules on how to handle the background: you, the artist, must decide on what you feel is the best solution aesthetically. Before you leave this section on oil painting, I hope you will review the successive steps of this demonstration to understand how I have constructed my final painting.

PASTEL PAINTING MATERIALS

Because many of the Keys in this book are illustrated with pastel paintings, I think it would be beneficial to talk a bit about working with pastels.

Until recent years, pastel was a greatly neglected medium, but thanks to the Pastel Society of America, it is finally gaining the importance and popularity it deserves.

First popularized in the 1720s by Rosalba Carriera, a Venetian, pastel has proven to be one of the most permanent of all the painting media. Unlike oil, watercolor, and acrylic colors, which have fluid vehicles, pastels are sticks of pure color that have been molded with a very weak solution that evaporates afterward; when dry, they are the closest thing possible to pure pigment.

Working with pastels should help you with your oil painting because the very nature of the medium forces you to arrive at the final hue by superimposing one color over another. It is desirable to apply this way of mixing color to your approach to painting as well, mixing your colors on the canvas rather than on the palette.

My whole process of working in pastel is based on the principle of the pigment releasing itself onto the surface of the paper as readily as possible. Consequently, I use only soft pastels, and I find the Rembrandt brand to be of excellent quality. Students often make the mistake of purchasing too small a set of colors; 90 sticks are barely adequate, and 180 sticks are much more desirable. I also find pastel pencils handy for sketching and for adding an occasional bit of detail, but their consistency—which must be harder so that the pigments can be encased in a wooden shell—is sometimes a disadvantage.

For preliminary sketching, never use an ordinary graphite pencil, as it often makes a line that will repel a later application of pastel. I seldom use an eraser, except for cleaning up a background that has become smeared or dirty, and occasionally for removing a passage. For this I have found the Lion brand plastic eraser, which is manufactured in Japan, to be excellent. I often wonder if the manufacturers realize just how well it works with pastels, for I never see it advertised for this specific purpose. For making major changes, and for removing a great deal of pastel pigments, I find a single-edged razor blade handy. I hold it at right angles to the paper and not only scrape off the unwanted pastel but also rough up the paper a bit before applying new color.

Pastels should always be done on a toned ground, never on white paper. Some artists have very elaborate procedures for pastel painting, such as underpainting with opaque watercolor. I don't feel this approach is in any way wrong, but I have always stayed with the relatively orthodox method of just applying pastel to a good paper. If you have not tried pastel, I suggest you stick to my simple approach, at least at first; many times, if a procedure seems too complicated, it turns the student off. If you haven't already tried this great medium, I hope that seeing my work in this book will encourage you to do so.

For my working ground, I use the wonderful high rag content Canson Mi Teintes paper, which is made in France and imported to the United States by Morilla. It comes in thirty-three colors, and if you write to Morilla at 221 Bowers St., Holyoke, Massachusetts 01040, they will send you a color-swatch book. This paper is produced in three sheet sizes and is available by the roll for larger work.

There are no rules for choosing the correct color of paper for a particular portrait. Like so many other aspects of art, this decision is governed by your own taste and feeling. Because much of the paper is left uncovered in a pastel painting, you need to select a paper that will complement and harmonize best with your particular subject. I take into consideration the color of the person's hair, flesh tones, and clothing.

In my discussion of oil colors, I told you I never

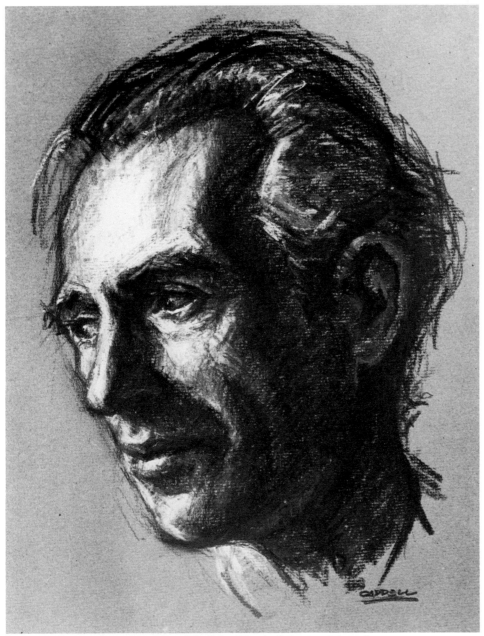

This quick study of a neighbor of mine was done in black, white, and gray pastel on toned paper. The man had a wonderful, strong face, and when I was doing illustrations, he was always very interested in helping me by posing. By taking liberties, such as adding a mustache, and varying his costume, I could turn him into many different personalities. One day I decided to make this study of him just as he was. It is an interesting challenge to see how profound a personality study I can make yet still do it in a spontaneous and artistic way.

STUDY OF ED, *pastel on paper, 14″ x 11″ (36 x 28 cm), Collection of the artist.*

use black, and so it may come as a surprise when I advocate its use in pastel. There are times, however, when it isn't possible to get the necessary depth of value with other colors. In such a case, I underlay with black and superimpose the local color on top of it. I will say, however, that you shouldn't use black if another color will do.

There are spray fixatives that can be applied to pastels, but I urge you to be cautious with these.

Don't feel that you can put on so much fixative that your work will not smear at all when you touch it. If you put on that much, you will darken your colors and values too much. Use fixative sparingly to solidify the pigment or to give the surface additional tooth in order to apply more pastel over it. I generally use very little fixative, and when my work is finished, I have it framed under glass as soon as possible to protect it.

PASTEL PAINTING PROCEDURES

One of the advantages of using pastel is that you can set up to work easily, stop at any time, and go back to work even for a few minutes without having brushes and a palette to clean. Pastel is a great medium to take on sketching trips for making either quick color notes or more profound studies.

When students first try pastel, their first questions often are "How do I apply it to the paper?" and "What sort of strokes do I use?" As understandable as these questions are, I usually tell them not to worry too much about these aspects of the medium but to concentrate instead on getting the correct colors and values in the right places. Since I often make comparisons to music, I tell them, "Show me that you can hit all the right notes. When you have achieved this, we will worry about finesse." My only caution is that, because the arm moves so readily from lower left to upper right, you should try to avoid the natural tendency to have a predominance of strokes at a 45-degree angle. Also, keep your fingers off your work—and don't use either your fingers or tortillions (blending stumps) to obtain the soft airbrush effect that became popular some years ago. This smoothing out destroys the wonderful spontaneity that is one of the outstanding characteristics of the medium.

My approach to using pastels is quite similar to the way I make an oil painting: I concentrate first on the big shapes and overall design. To make a successful pastel portrait, you have to be able to draw exquisitely. When you are able to do this, you will be free from the temptation to draw everything in too much detail in the beginning stages. I have often heard students mistakenly say, "I don't want to start putting color on until I have it all drawn in well." This seems to be the greatest difference between the the amateur and profes-

sional artist. The amateur finishes the picture too soon, getting right into the details, whereas the accomplished artist spends a great deal of time working out the design elements, balancing and relating colors and values to one another. Only when all this is accomplished does the artist start refining.

The main difference between the approaches to pastel and oil is that when you use pastel, you work on a toned ground, a surface that is not white but a middle value. Because of this, you put on lights as well as darks when you begin to establish your complete value range for analysis.

There is not space in this book to go into all the technical aspects of pastel here, but much of this will come to you naturally as you experiment with the medium. Of course, the harder you press the stick, the more pastel will come off on the paper. Unlike oil paint, pastel does not lend itself to extensive correction, for the paper reaches a point where it cannot accept any more pigment. Nonetheless, it is amazing how much pastel a good paper will take. As a rule, when you are building up a composite color, you should put on the darker base color first. Many times this color needs to be darker than the final value you want to achieve, in order to compensate for the lighter value of the local colors that are placed over it. As I have said, the skill to do this will develop with enough practice, as was the case with me. As with oils, if you enjoy using pastels your work eventually will show your great love of the medium.

Normally a pastel portrait takes about three sittings. If it takes longer, then you are likely to be just fumbling and correcting mistakes—for if you have something to say, you should be able to say it in a positive, constructive way right from the start. The demonstration on the following pages will show you, step by step, how I work in pastel.

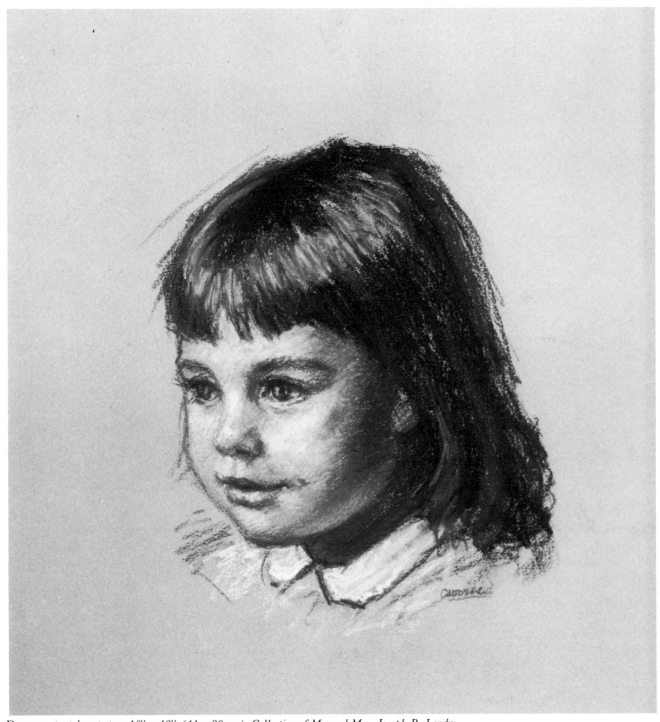

DONEEN, *pastel on paper, 16″ x 12″ (41 x 30 cm), Collection of Mr. and Mrs. Joseph R. Landry.*

This young girl was a delight to do, and I found the simple round form of her face intriguing. Artists often select their models from among older people who have character in their faces, but although these faces are often fascinating to paint, I think youth and beauty are harder to capture.

Notice how the reflected light from the collar and dress helps model the fullness of the lower face. The little round button nose has been shaped so that it comes away from the cheeks. See how sensitively the mouth is formed; you

can actually feel the roundness of the lower lip. In doing the hair, I looked for the patterns created by the light falling on it. Dark hair can become quite light and have many lovely variations in color if you learn to look for them.

When I went to borrow this portrait to have it photographed, I met the young lady again after many years. I thought to myself that it would be interesting to be able to portray the same individual in different periods of development.

Pastel Demonstration

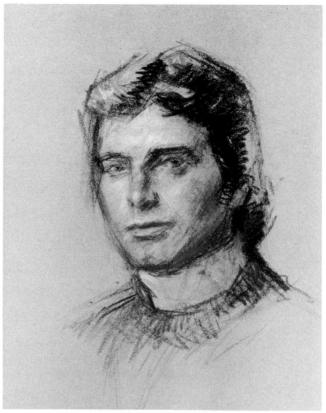

1. SKETCHING IN THE HEAD. This step-by-step demonstration was actually done for a class and photographed at each step of the procedure. Notice how sketchily the entire head is conceived. My first concern is its size and placement, and I go after the big design. I suggest the features lightly, but notice their lack of specific definition and placement at this stage. I rough in the great mass of dark hair with strong black strokes. By indicating an illuminated front plane and a shadow side, I make the head solid right away. Right up to the end, I will retain the freedom that is evident here, even though I will constantly refine the portrait.

2. ESTABLISHING THE VALUES AND COLORS. Now I study my sketch and decide I don't like the pose I established in the first step. I feel a greater angle of the head will be much more interesting, and so I start the project over again on a fresh sheet of paper. This is a good lesson in why you should catch your mistakes at the early stages, when it is easiest to correct them; you can see how crucial this early portion of the work is.

After a new start, I begin to give more attention to the lighter side of the face and search for all the possible variations of color. I indicate the lips with warm red so that I can compare this against the amount of red I find in the cheeks and the rest of the face.

I don't spend too much time in the light areas without bringing the shadow passages along also. Shadows give luminosity to the lights and make for a good solid conception. Notice that where the shadow area starts along the nose, cheek, and chin, the value is darker. There is quite a bit of color in the cheek, where the shadow gradates into the light passage, and then the color is diminished by the greater amount of illumination in the lightest areas.

Be careful not to misjudge the values in an area like the ear, which appears lighter than it is because it is surrounded by darks. This is a common mistake. Just remember that the ear is on the shadow side of the face.

Gradually I mold the features, using color and values to create the illusion of three-dimensional form, as if I were a sculptor modeling with clay. Even at this stage, I resist being too specific about any of the features in particular; you can see this in the way I handle the eyes.

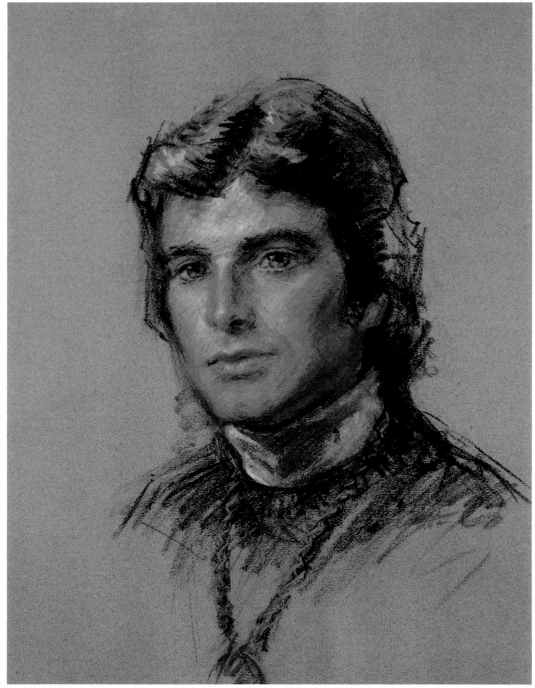

THE STUDENT PRINCE, *pastel on paper, 17¾″ x 13¾″ 45 x 35 cm), Collection of the artist.*

3. PULLING IT ALL TOGETHER. Now I set about bringing my entire concept to a conclusion. Notice how much of the gray paper is still left in the light area of the hair. To give an overall unity to the picture (I shall go into my theory on this in more detail later) I use a little of the flesh color for lights in the hair. Even though I am now defining features, notice how softly and freely these passages are handled. I render the edge of the face on the left side with different degrees of sharpness: where the cheek and the chin take a more acute turn, I give the face more definition than in the area in between, which goes farther back to the jaw line.

I carry the turtleneck sweater further, but it still is only suggested, as is the pendant around the sitter's neck. I bring the dark of the hair down so that it joins the dark of the sweater. (This is discussed in detail later on, in one of the Keys.)

Notice how many of my original sketch lines are left in the finished portrait, showing how I searched for definite edges in the shoulders. Pastel seems to lend itself to this free, sketchlike approach, but you have to be able to buckle down and define forms more concretely where necessary. The secret is to do this in a way that doesn't look labored.

LITTLE LOUIE, *oil on canvas, 18″ x 14″ (46 x 36 cm), Private collection.*

The Keys

Creating a Convincing Three-Dimensional Head

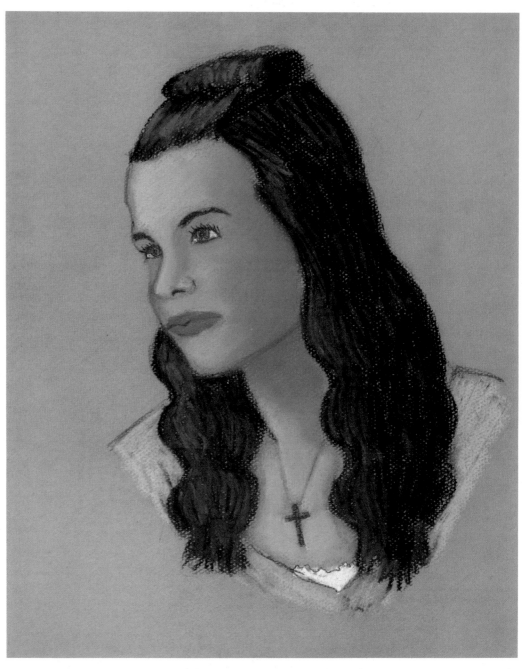

BAD. In this Key, I want to take up one of the most important principles in portraiture: the necessity of producing a solidly constructed head. Too often students are so concerned with getting a likeness that they fail to meet this important criterion. In this pastel there are many mistakes that I shall take up in detail in successive Keys, but the main fault I want you to notice here is that the entire concept is flat. There is no feeling that the head is a solid object existing in space. This is because the artist has not shown the effects of light playing on some of the surfaces or the shadows that occur elsewhere as a consequence of that light. Lacking solidity because of the absence of modeling, the features are drawn in line—a solution that is absolutely wrong.

There is also a stiffness to this painting because every single stroke that extended beyond the outlines of the head has been carefully erased. (Compare this version to the casual handling of color in the painting on the opposite page.) The flesh tones here are not only monotonous in color and value, but also have been carefully smoothed out with the fingers—which is a cardinal sin! The hair hanging down in the same way on both sides of the face makes for a repetitive design. See how much more interesting the other version is. I won't go into the other mistakes you see here, but try to define them specifically for yourself. If you can't identify them now, come back after reading the remaining Keys and see whether or not I have taught you to see errors more easily.

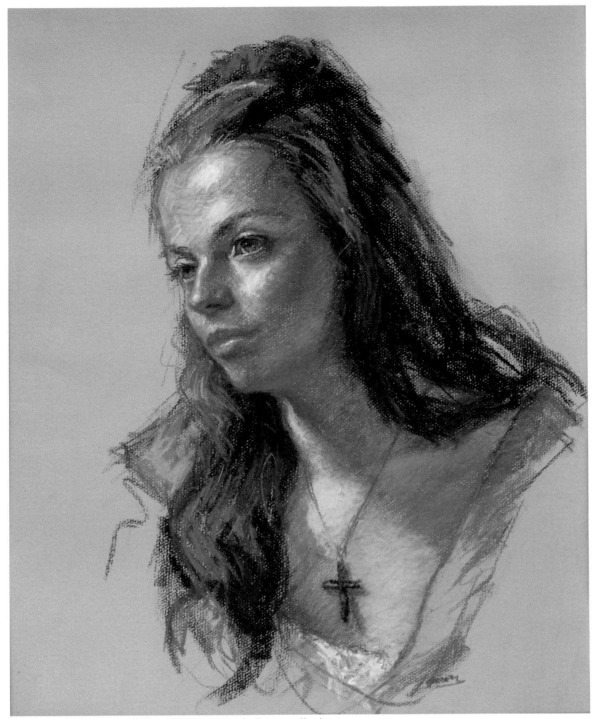

Pensive, *pastel on paper, 20″ x 16″ (51 x 41 cm), Private collection.*

GOOD. A three-dimensional effect in a piece of two-dimensional artwork is purely illusory, of course. The artist brings it about by the study and execution of the correct values, which are created by the presence or absence of light on a particular surface. These values are what we see in reality, and when they are depicted accurately in a painting, we subconsciously become convinced that the flat surface represents a solid three-dimensional object.

The play of light has been rendered in a way that makes the forehead look round. The cheek turns convincingly from the illuminated front to the shadow side of the head. The nose protrudes from the face. The lips have form. All this is created by recording the presence or absence of light.

The greatest pitfall of the student is making assumptions about what the solutions are, rather than seeing and rendering them literally and accurately. This tendency is what I hope to help you overcome.

2. THE KEY TO
Exploiting the Color Possibilities in Flesh Tones

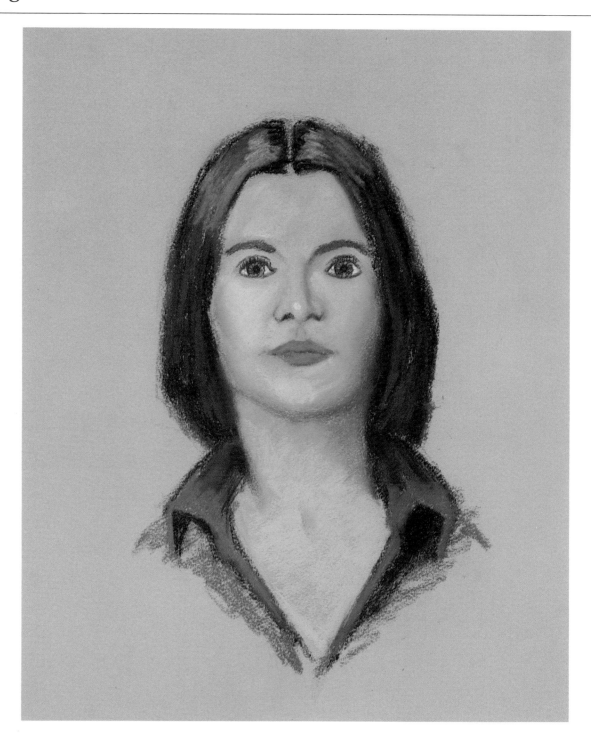

BAD. Here we see the results of an inability to recognize any variations in flesh tones. This kind of thinking is carried over into the treatment of the hair and the blouse also. Except for a bit of shading, this example demonstrates what I often refer to as "house painting." Lack of attention to variations in color and value within local color areas makes the entire conception flat and uninteresting. This is true not only of the head as a whole but also of the individual features. Notice the lack of modeling in the eyes, nose, and mouth.

Students seem to think of all flesh tones as variations of a creamy burnt sienna. They even expect the teacher to give them a formula for mixing it, much as a paint store mixes house paint. Of course, all this is the result of the inability to see the beautiful colors that actually exist in the flesh tones of the model in front of them—and the failure to use a little artistic interpretation in exploiting every variation. Notice also that the blouse in this example is rendered in a monotonously symmetrical way; compare it to the much more interesting version opposite.

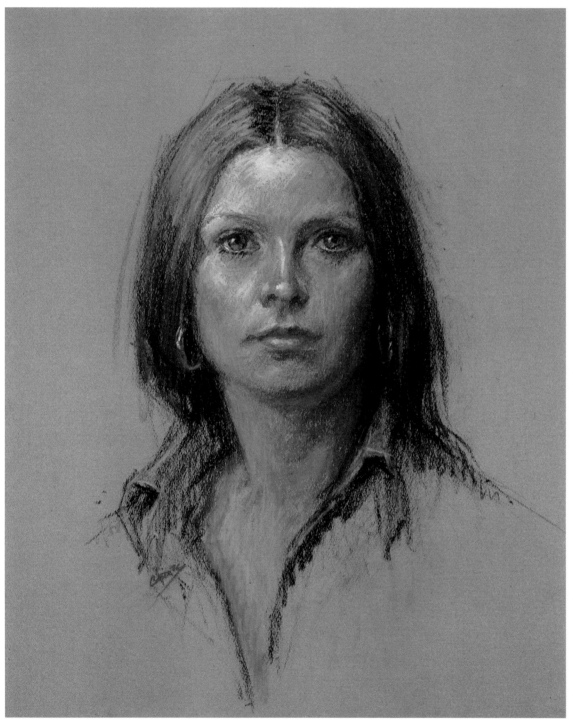

Diane, *pastel on paper, 17½" x 14" (44 x 36 cm), Collection of the artist.*

GOOD. You will find that a dominant theme keeps recurring in my teaching—the fact that amateurs have trouble analyzing correctly what they see before them. Because of this, they oversimplify their solutions to color, and they end up painting what they think they see: in landscape painting, water is "blue," grass is "green," and the tree trunks are "brown," and so on. Students extend the same kind of thinking to portraits when they paint flesh tones.

Observe the variations in color that I have used here; they are not usually thought of as "flesh" colors. There are blues and subtle purples in the shadow side of the face, and some green from the blouse is reflected on the underside of the jaw. I give you only one word of caution. Exploit all the color variations you can find, but do not go so far that an area no longer looks like the basic color it is. In other words, do not carry the use of cool complementary colors so far that the flesh no longer looks healthy.

Positioning the Angle of the Eyes

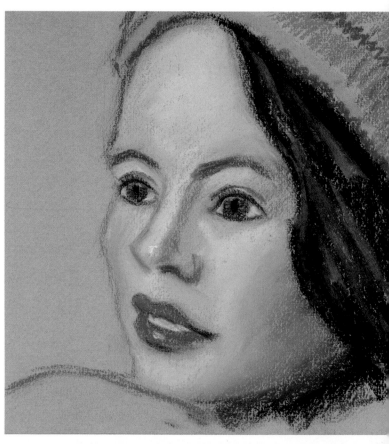

BAD. This sketch shows the common tendency to make the eyes level instead of consistent with the tilt of the other features. Many times mistakes like this can be spotted readily by looking at the reversed image of your work in a mirror.

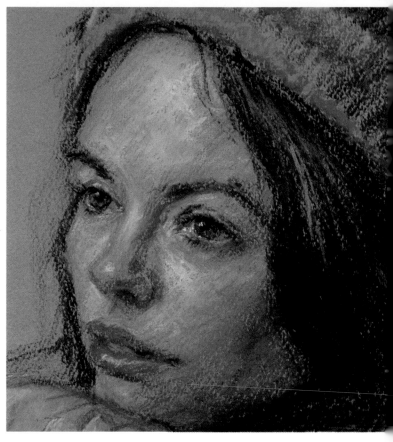

GOOD. In this detail of the painting on the opposite page, you can see what I mean about the orbital lines being not only at right angles to the center line but also consistently parallel to each other. Establish the correct angle of the features in your work right away, and don't change it even if the model "drifts" a little from the original pose.

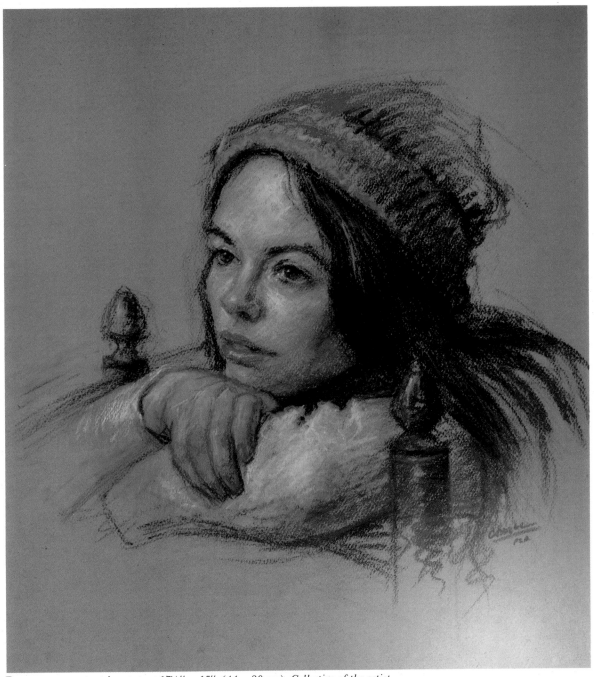

DAYDREAMING, *pastel on paper, 17½" x 15" (44 x 38 cm), Collection of the artist.*

GOOD. Positioning the features requires a combination of keen observation and the knowledge of what is *supposed* to happen. Imagine that a vertical line runs down the center of this young woman's face. You can see that the eyes, like the other features, would be aligned consistently along imaginary parallel lines going around the face, at right angles to the vertical one. With few exceptions, and these I tend to minimize, this would be true of most people's faces. If a student does not have this angle correct in depicting a pose like this one, it is because the eyes are drawn either at too great an angle or too little an angle. Students rarely position the eyes at *too great* an angle; re-gardless of the pose, the angle is usually too small and therefore the eyes are somewhat horizontal and not at the same tilt as the head. We all "know" that eyes are basically horizontal, but try to watch out for the tendency to apply this principle incorrectly in your work.

In posing your sitters, you should try to avoid repeating the same pose over and over again. Varying the pose will give you practice in painting the model with different tilts of the head. Models are wonderful, live creatures, and because of this, even the best of them move. (That is why we call studies of inanimate objects "still lifes"!)

Keeping Individual Eyes at the Correct Angle

BAD. Here the *general* position of the eyes is correct in relation to the angle of the nose and mouth, but each individual eye has been "leveled off" and is inconsistent with that angle. Many students have difficulty drawing the inner corner of the eye higher than the outer corner, as you can see in the eye on the right. When faced with an unusual pose, amateurs have trouble seeing that the shape and placement of each eye changes with the tilt of the model's head; most students will revert to drawing the individual eyes the way they are most accustomed to seeing them.

GOOD. Notice that because of the tilt of the model's head in this close-up of the portrait on page 41, the outer corner of the eye on the right is lower than the inner corner. Having seen their own eyes in the mirror for years, amateurs often want to place the inner corner lower, where they feel it should be. Also observe that the pose determines the effects of light and shadow on the values of local color, which is not always what we think it should be: here the so-called white of the eye on the right side of both eyes is actually darker than the light edge of the eyelid below it.

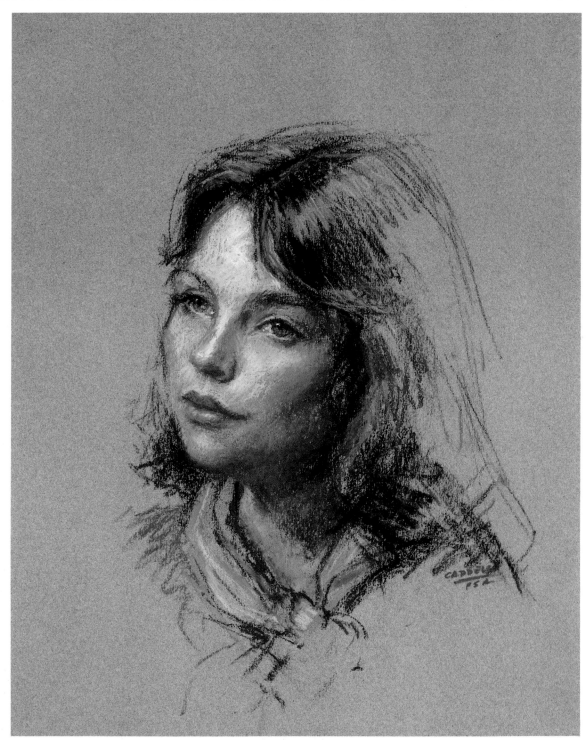

Linda, *pastel on paper, 17½″ x 14″ (44 x 36 cm), Private collection.*

GOOD. In the previous Key, I discussed why students often fail to keep the general angle of the eyes consistent with that of the nose and mouth.

Once they become aware of this, however, students still have a tendency to allow their previous thinking to creep in again when they paint each individual eye, leveling it off as shown in the example opposite. I believe this often happens because as a model tires, she tends to straighten her head to a more comfortable position. The answer to this problem is not to criticize the model every time she drifts, but to commit the pose to paper at a definite angle right away and stick to this angle even while you are involved with other problems such as color and modeling. When you can become aware of these tendencies in your own work and catch them at an early stage, you are well on the way to more professional-looking work.

5. THE KEY TO
Painting the Whites of the Eyes

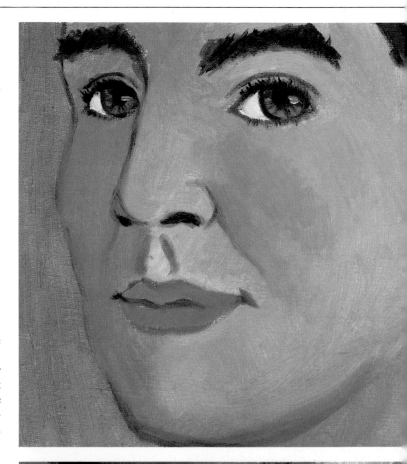

BAD. Painting the whites of the eyes too light a value creates greater contrast than actually exists in reality, and therefore it brings undue attention to this area of the face. All the flesh tones here are treated much too simply and monotonously. Compare them to all the beautiful variations in color that you see in the good example. There is not enough contrast in the flesh tones here, and the shadow side of the face, which depends on color differences rather than values, does not contrast with the background.

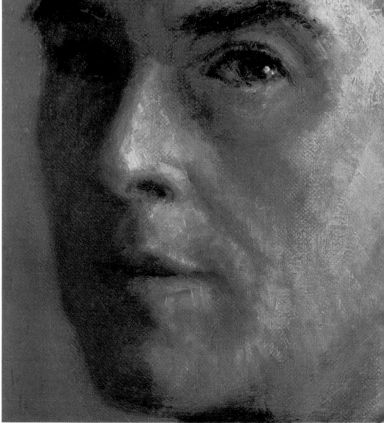

GOOD. The eye is a round ball that curves as much as the end of the nose and the chin. In this portrait, the left sides of the nose and chin are in shadow. Logically, then, the left side of the eye on the right also must be in shadow. Naturally, the eye on the left must be completely in shadow, since that whole side of the face is shadowed. When rendering grays in these shadow areas, try to introduce various colors instead of using just Payne's gray and white.

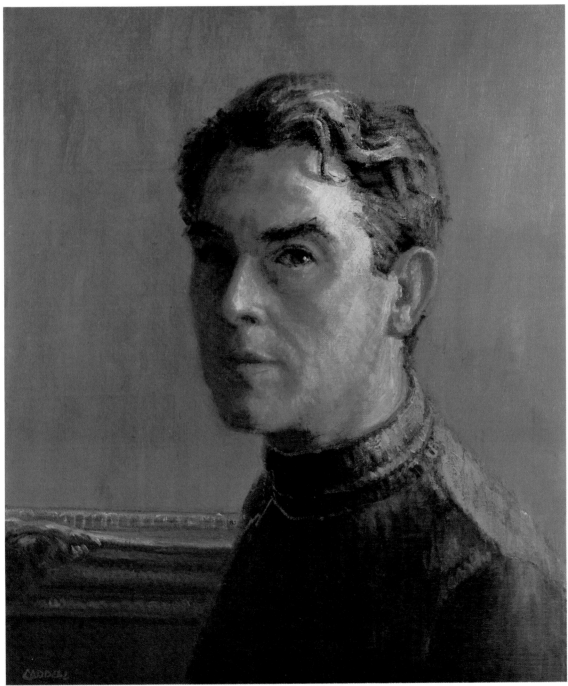

SELF-PORTRAIT, 1961, *oil on canvas, 20″ x 16″ (51 x 41 cm), Collection of the artist.*

GOOD. In all my years of study, no one ever stressed to me the important fact that students do not see objects as they actually appear. When I started teaching, I found this to be such a prevalent weakness that I cannot stress it enough to my students. In the previous Keys I have shown how this problem applies to drawing; here I want to elaborate on how it applies to values.

We all know that the area of the eye not taken up by the iris and pupil is "white," but artistically this isn't always so. Any white area that is in shadow and does not have direct light hitting it cannot be a bright, high-key white,

and this applies to eyeballs as well. You must know this principle so well that you won't be fooled by what you think you see.

The way to determine the values of the eyeballs is to squint your eyes very tightly as you study the model. Compare the whites of the eyes not only to the dark areas around them, but also to a lighter area as well—in this case, it is the right side of the forehead. A simple rule is if light is not shining directly on an area, then the area probably will be darker than the value you would normally assume it is.

43

Positioning Features in a Three-Quarter View

BAD. Here, the left eye is too far away from the nose and the right eye is too close to it. In a three-quarter view like this one, the farther eye should also be a bit smaller than the nearer eye, but this principle of perspective has been overlooked in this painting. There is also, of course, too much space on the far side of the face, which should be somewhat foreshortened. The color is bad, and because the proper colors and values have not been used, there is not sufficient modeling of form.

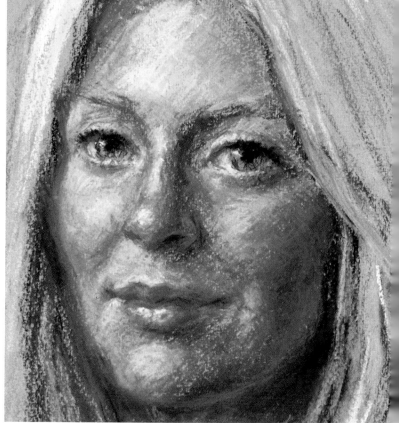

GOOD. In working with a pose like this, keen observation should tell you that if you were to drop a line from the inner corner of the left eye, it would align with the left side of the ball of the nose. A line drawn down from the inner corner of the right eye would just miss the nostril below it. The amount of cheek area that shows to the left of the nose is less than the width of the entire nose. You must learn to observe and record these changes in alignment and proportion exactly.

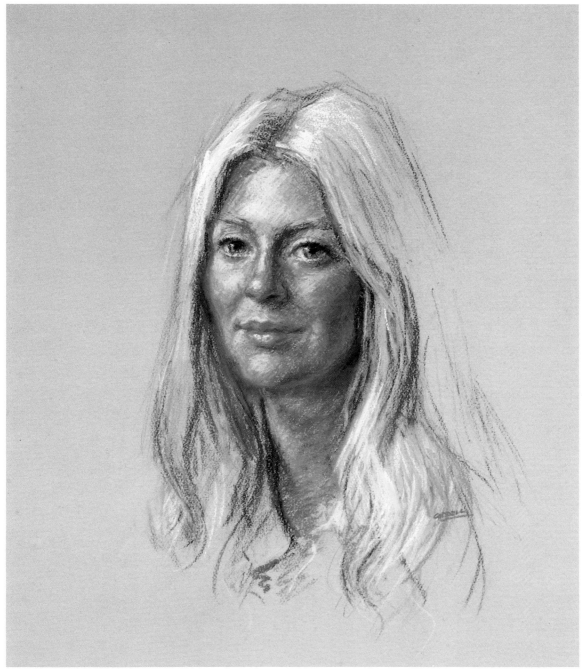

Mrs. Jan J. Akus, *pastel on paper, 19" x 15" (48 x 38 cm), Collection of Dr. and Mrs. J. J. Akus.*

GOOD. Perhaps you never realized that most amateur painters make the same types of mistakes. I didn't realize this myself until I started teaching. Mistakes are caused by a lack of experience and knowledge. If you do not have a competent teacher watching over your shoulder as you paint, you need to learn to spot these predictable errors in your work for yourself. I hope that these Keys will teach you to do just that.

When dealing with a three-quarter pose, students often make the common mistake of moving the features toward the center of the head. This leaves too much space on what should be the smaller side of the face—the left side, in

this portrait—and brings the right eye too close to the ear, when it is visible. I seldom see students foreshorten so much that they make the far side too small; usually it is too big. For some reason people tend to gravitate toward a frontal view—probably because it is easier for them to think of a face as symmetrical.

As the head turns, the far eye should appear closer to the nose and the near one, farther away from it. Another problem area, however, is the tendency to make the far eye too far away from the nose and the near one, too close. Try to watch how the eyes align with the nose.

Modeling a Nose So That It Protrudes

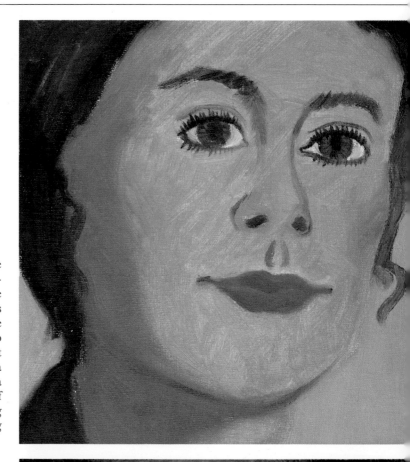

BAD. Many students paint noses that look like the one you see here. There is no appearance of three-dimensional form because the different values have been neither observed nor rendered. Because of this deficiency, lines have been used here to define the features, and we are much too conscious of the two dark nostril holes. It is safe to say that if you cannot use values to model a rounded object such as a peach or a grape in a still life, you cannot model a nose—or, for that matter, any other facial features. If you are having trouble with this aspect of modeling the features, I suggest you practice by painting simple rounded still life shapes.

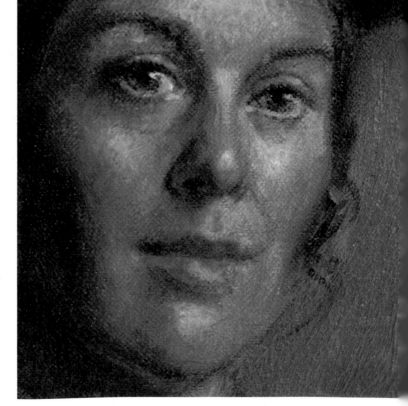

GOOD. Here is a nose that you feel you can take hold of. The proper values were used to model it, and the graduated values in the light areas culminate in the highlight on the tip. In the shadow area, the darkest dark is on the side of the ball of the nose. The protruding nose creates cast shadows on the left side of the face and also on the flesh directly beneath it. As you can see here, there is usually a reflected light in the area around the nostril.

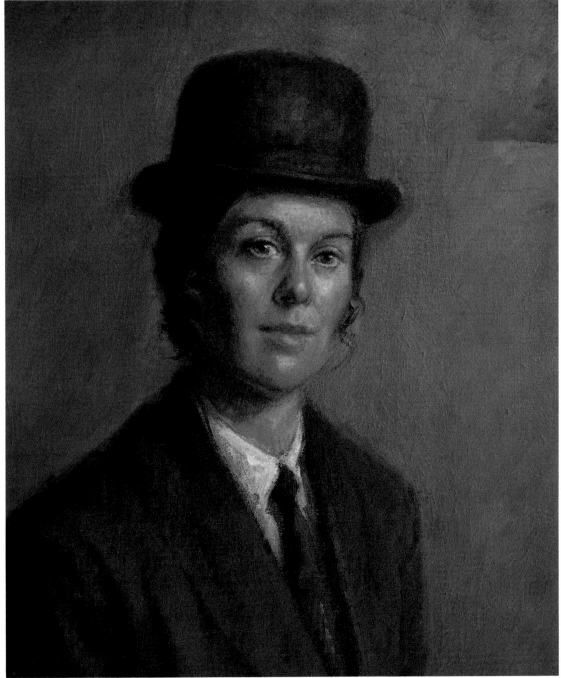

CAROL *(detail), oil on canvas, 36" x 30" (91 x 76 cm), Private collection.*

GOOD. The example I am using here and opposite is a detail of one of my large oil portraits (the entire painting is reproduced on page 76). By studying this enlarged close-up, you can compare its execution with that of the pastels in this section of the book. The area shown in the close-up on the facing page is a section of the face that is approximately 6″ (15 cm) square on the original painting. It shows how I render a head in a formal, commissioned portrait. The handling is somewhat more refined than that of my informal portraits, but it is still soft and artistic, for I dislike a slick, photographic effect. This portrait is a

good example of a solidly modeled head, which I discussed in Key 1. The subject of this painting is very restricted in color because of the dark blue riding jacket and black derby. The greatest use of color is in the face. Notice that each individual feature is modeled so that it looks like a solid form. This is of the utmost importance.

In landscape painting, three-dimensional space may cover distances of many yards or even miles. In a portrait you must also create the illusion of distance, but you are dealing with inches or less—for instance, the distance between the nose and the rest of the face.

Making the Mouth Curve Around the Face

BAD. Everyone "knows" that the mouth tapers to a corner on each side, and it seems difficult for many amateurs *not* to portray it that way—even when it doesn't. This is just another example of putting down what you *think* is the solution instead of learning to see accurately. People often paint the lips as if they were applying lipstick—with the same color and value from top to bottom as you see here. Another common mistake is delineating the teeth too clearly.

GOOD. As a mouth curves around the face, we quite often do not see the far corner where the lips taper and converge. Because the lips in this example were painted with variations in color and value, they have form. The teeth, which are often shadowed by the upper lip, are not as bright as the highlight on the lower lip. Notice the lack of specific definition, and how darkening the left side of the teeth has given them form within the lips.

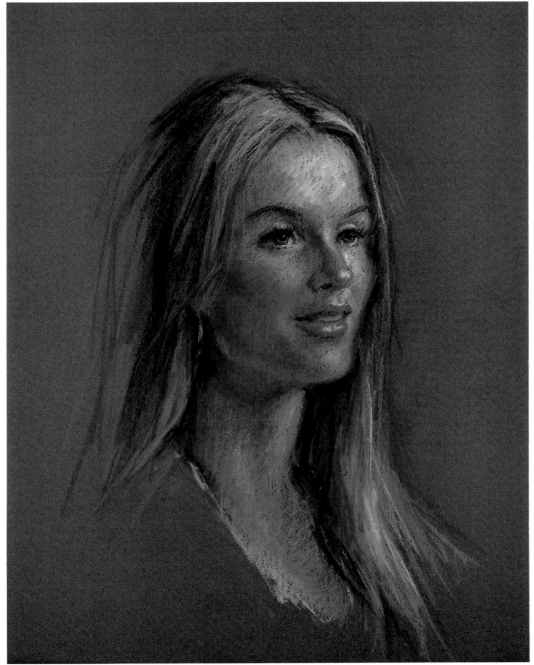

Claire Paradis, Rose Arts Festival Queen, *pastel on paper, 18" x 14" (46 x 36 cm), Chelsea Savings Bank Award, 1975.*

GOOD. It is often said that a portrait is a picture of someone that "has something wrong with the mouth." Mouths are difficult, and in this Key I take up one of the most common mistakes students make. Basically, it is a failure to give the mouth form and dimension, and it is caused by drawing the mouth wrong—again, the way the student *thinks* it looks rather than the way it actually does appear.

For this pastel I used a dark brown paper (no. 26). By creating greater contrast, this dark tone gives more brilliance to the lights, and it also helps my rendering of the darker end of the value scale. Of course, this choice of paper requires a heavier application of pastel in the light areas, for that which is advantageous in the darks is a disadvantage in most of the lights.

The model is obviously a blonde, but see how I achieved the hair color with various hues, as I discussed earlier.

Notice that the value of the chin is slightly lighter than that of the light area of the neck, which is adjacent to the dark shadows in the hair. Because of the contrast, such an area often looks lighter than it really is, but by creating a subtle value difference I brought the chin forward, maintaining a sense of space and distance. Had I painted the lights in the chin and neck the same value, I would have flattened the overall effect.

49

9. THE KEY TO
Painting a Smiling Face

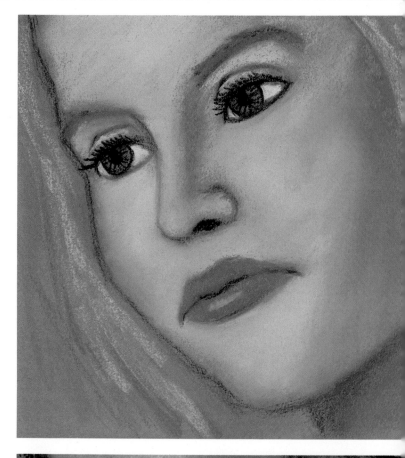

BAD. If all art students were to try modeling, they would realize that posing is not as easy as it looks— and they would be more sympathetic to the model. Posing can be tiring, and many times the fatigue shows on the sitter's face. The artist must master the situation and not portray the model as has been done here, even though it is difficult to capture a fleeting expression. This is why it is important to train by painting objects that don't change or move.

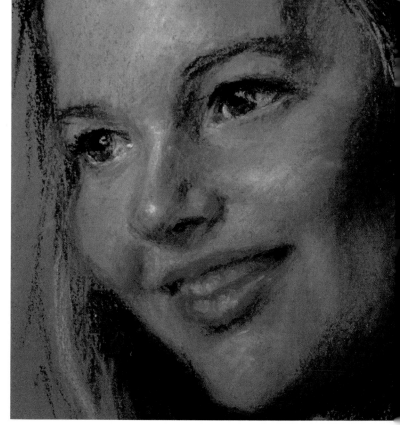

GOOD. When the model smiles, you must notice how much each individual lip curves. How aware of the teeth are you? How pronounced are the smile lines? How round does the cheek become, not only on the near side but on the far side—and how does the profile change on the far side? Another point to consider is how the eyes are affected by the smile. Do they get larger or smaller? All these elements must be considered when you depict a smiling face.

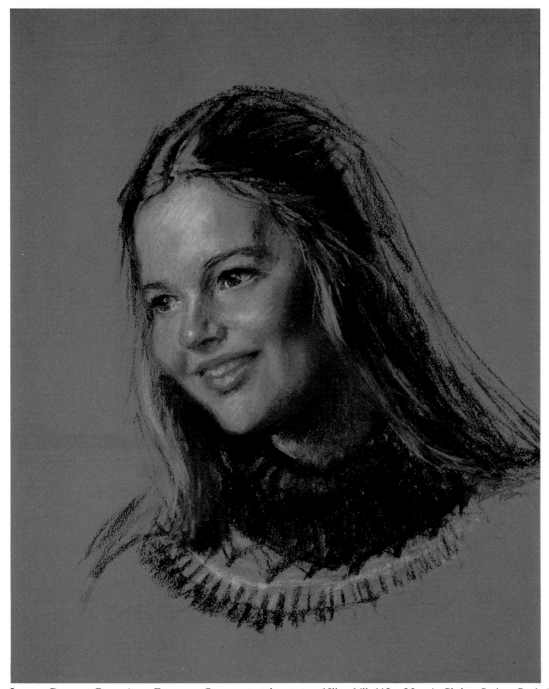

JUDITH GLENNY, ROSE ARTS FESTIVAL QUEEN, *pastel on paper, 18" x 14" (46 x 36 cm), Chelsea Savings Bank Award, 1977.*

GOOD. After you have mastered the *craft* of painting, your big problem is deciding on an interpretation of your subject. In other words, the question of "how to do it" is replaced by "what to do." This is such an important factor in painting that the "how to do it" must become almost automatic so that the artist is free to deal with the more aesthetic side of portraiture.

How do you decide on the angle of the pose, whether it should be a formal or informal one, and what mood or expression to depict? These are vital decisions. Some people are very dignified, while others are just bubbling over with good humor. The smiling face is not easy to paint because it is difficult for the model to retain the expression, even if he or she is a very pleasant person. Another problem is deciding just how much of a smile is most desirable. The approach I use is to talk to my model about humorous subjects; as the person talks and smiles, I quickly analyze just what happens to the entire face as well as the mouth. It is still not easy to paint a smile, as I am depicting a memory image of a fleeting effect. With practice and training, however, it does become easier.

51

Keeping the Hairline Soft

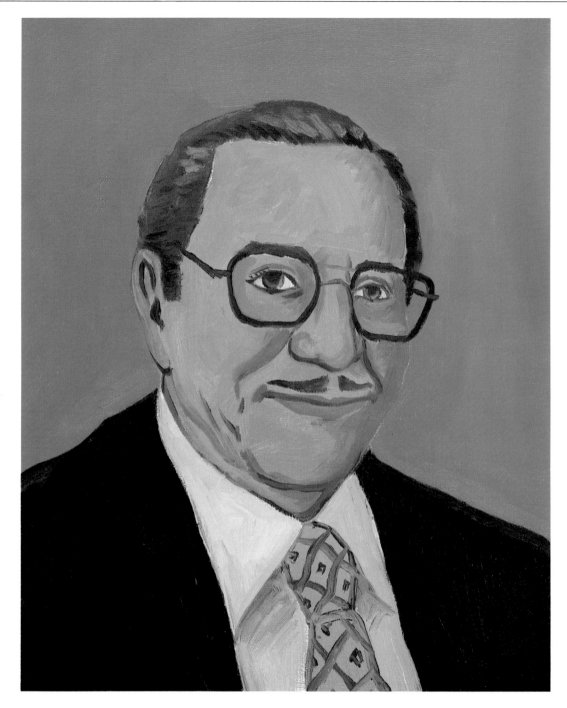

BAD. Here you can see an effect that many students get when they define the hairline too specifically—it makes the hair look like a toupee. Why? Because there are no soft transitional edges showing how the hair really grows out of the scalp and the flesh shows through.

If you draw the hairline as a single line and use too much medium, its edge will be too sharp. You should not be making clean, hard edges with each stroke, as if you were a calligrapher. To avoid this, try not to outline the hair with the paint; but if you feel you must do it in order to establish the correct contour, be sure to go back and soften and blend the hairline so there are no hard edges

left. Much of your subject's personality may be unintentionally changed by your mishandling of areas such as the hairline or eyebrows. If you paint a thin, hard, waxed-looking mustache on a man, or severely penciled eyebrows on a woman, you might alter not only the sitter's appearance but also his or her personality.

Notice the other painting mistakes that were made in this example: the uninteresting, monotonous flesh color; the lack of modeling because not enough consideration was given to subtle value changes; and the fact that the values in the head do not register properly against the background.

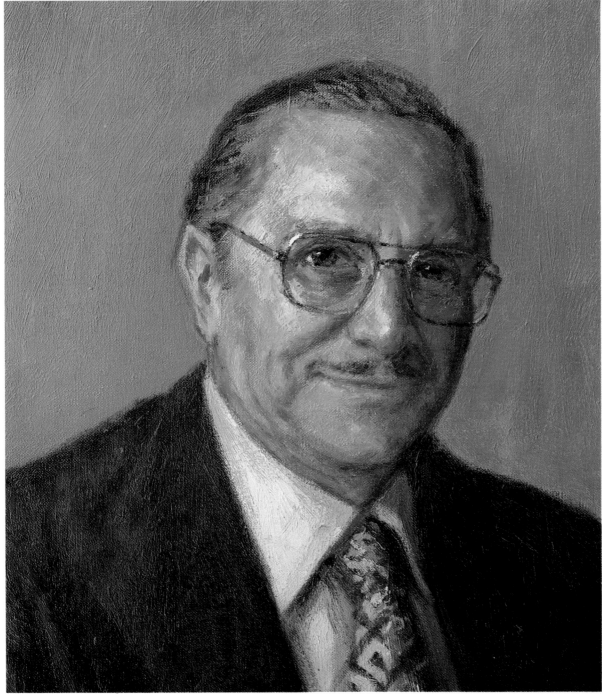

MR. C. JOSEPH SCOLA (DETAIL), *oil on canvas, 36″ x 30″ (91 x 76 cm), Collection of Mrs. C. Joseph Scola.*

GOOD. This is a close-up of the portrait I painted in the demonstration on pages 23–25. Notice how softly I treat *all* the definition in the head, especially the hair. I am not referring to just the area on top of the head: I want you to study the handling of the eyebrows and mustache as well.

See how the flesh color on the left side of the forehead is blended into the hair along the temple and sideburn. On the right side, the shadow value flows into the hair also. Another point, which I will discuss later on, is the soft handling of all *outer* edges; this helps to make the entire

head look three-dimensional. And while you are studying this close-up, notice also how I have handled the flesh tones in the areas where the man's face has been shaved. These areas can give you a wonderful opportunity to find subtle cool colors that contrast with the warm flesh tones, but the decisions you make here are critical. Handled correctly, these tones can convey masculine flesh; overplayed, they can turn a clean-cut gentleman into a burly chap with a five o'clock shadow.

53

11. THE KEY TO
Modeling a Bald Head

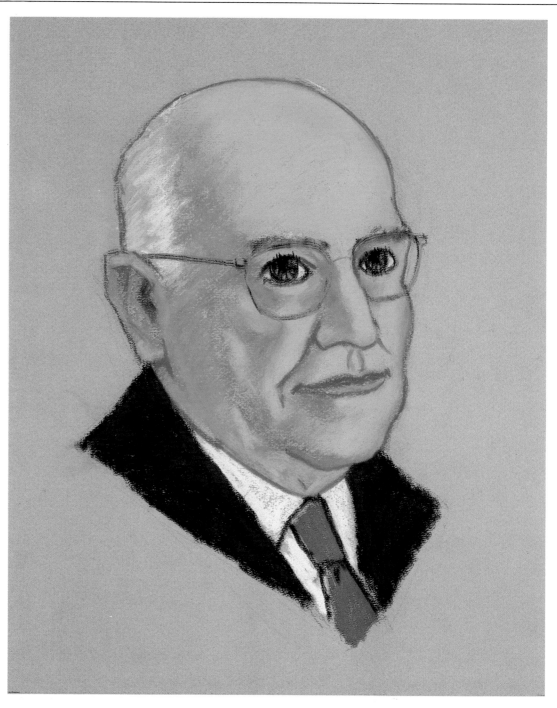

BAD. Often in concentrating on depicting a particular person, amateurs miss many important artistic possibilities that would make their portraits exist as good, solid pieces of artwork as well as likenesses. In this bad example, there is not enough indication of solid form existing in space. The shadow passages are not dark enough, and forms have been defined with lines instead of being modeled with color and values. I am too honest with you to pretend to give you special formulas or color mixtures to solve painting problems like this one. You should have noticed how widely the flesh colors differ in each portrait.

The real solution is simple, but it requires a great deal of work on your part. If you have trouble modeling a bald head correctly, go back and spend more time doing still life painting, modeling dozens and dozens of round objects in your studio. Search for form and beauty instead of just trying to record facts.

There are only four basic forms on the face of the earth: the cube, the sphere, the cylinder, and the cone. All others are variations of these. Learn to mold them well with your paint, and you will be able to model a terrific bald head or any other form that you encounter in painting portraits.

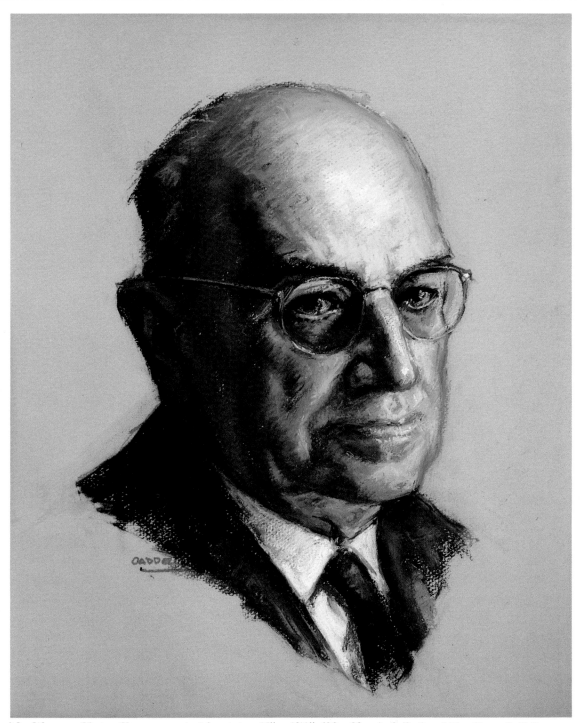

MR. WILLIAM HENRY KAUFMANN, *pastel on paper, 15" x 12½" (38 x 32 cm), Collection of Mrs. Foster Caddell.*

GOOD. Many years ago, at my wife's urging, I made a pastel study of each of her parents. I'm glad she persuaded me to do so, for I'm afraid that often, we artists are guilty of the "shoemaker's children" syndrome. The gentleman depicted here was my father-in-law, and I am pleased to include his portrait in a book of my work. In the absence of my own father, he did much to help and encourage me in my desire to paint. I only wish he could have lived to see these books justify his faith in me.

Many men do not have a good head of hair, but what may be a problem to them is an opportunity for the artist to model a beautiful head. Even though this portrait was done primarily as a record of the man, I was keenly aware of the artistic and aesthetic challenges that existed as I modeled the entire head, particularly the top section. With gradations of color and value, I strove to make a solidly constructed form that looks as though you could put your hands on it and actually feel the skull.

55

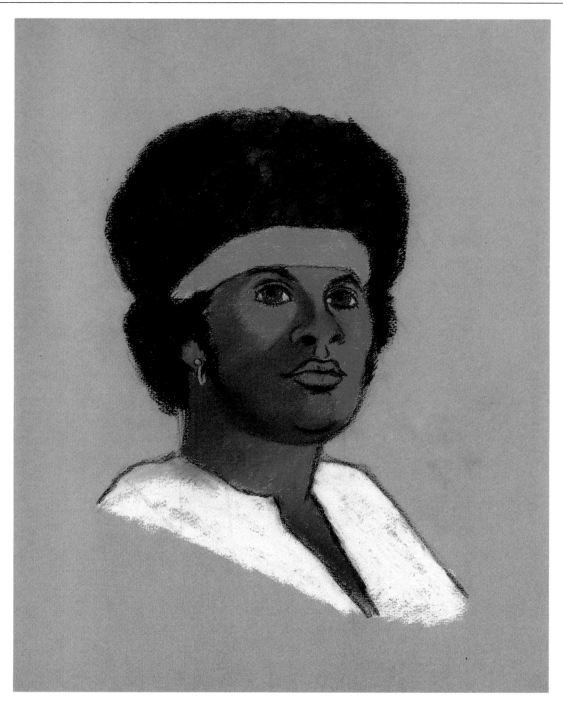

BAD. As I write this text, I am reminded of many pieces of classical music in which a basic theme keeps recurring, with some variations, throughout the score. In this book, I keep reiterating a basic theme: Do not revert to clichés in solving your painting problems. In this example, the flesh has been rendered in a monotonous dark tone that does not vary much in color or value. In Keys 5 and 24, I demonstrate that "white" is not always white. In this Key, I am stressing the same principle but at the opposite end of the value scale—that "black" is not always black—or even, as in the case of this model, a brownish black.

Believe me, you can train yourself to become more sensitive to color differences. It is like fine-tuning a violin. Learn to look for subtle variations in color and value caused by the play of light over the features. Study the model to see if colors are reflected up into the shadow areas from the clothing.

Also notice that in this example the face, hair, and garment have been handled as separate, unrelated items. In the good example opposite, they all flow together and become part of the whole, with the dominant color of the lights in the flesh repeated in the hair and as construction lines in the robe.

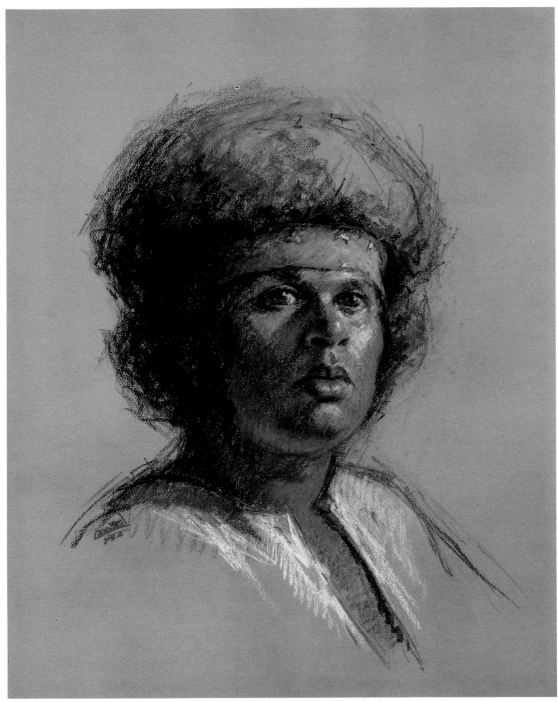

BLACK IS BEAUTIFUL, *pastel on paper, 21″ x 17″ (53 x 43 cm), Private collection.*

GOOD. The colors that can be found in dark skin tones are as varied as those in lighter skin. That is why I wonder why some teachers pretend to give the student a color-mixing "formula" to solve the problems of painting black people. There are no secret formulas—you just learn to paint the colors and values that you see before you in an artistic way.

The most important advice I can give you is this: Demand of yourself that you mix colors accurately, even when you don't have to. In your still life training, match the colors you see in cloth, jugs, or other objects as closely as you can—not just for the sake of being accurate, but as an investment in yourself. Someday it will give you a wonderful feeling to know you can match any color that you see.

The model for this pastel was a student of mine. I found him so interesting, I had to make this study of him. To me he looked as though he could have been a regal prince in some bygone period of history.

Using a Dominant Color Throughout the Painting

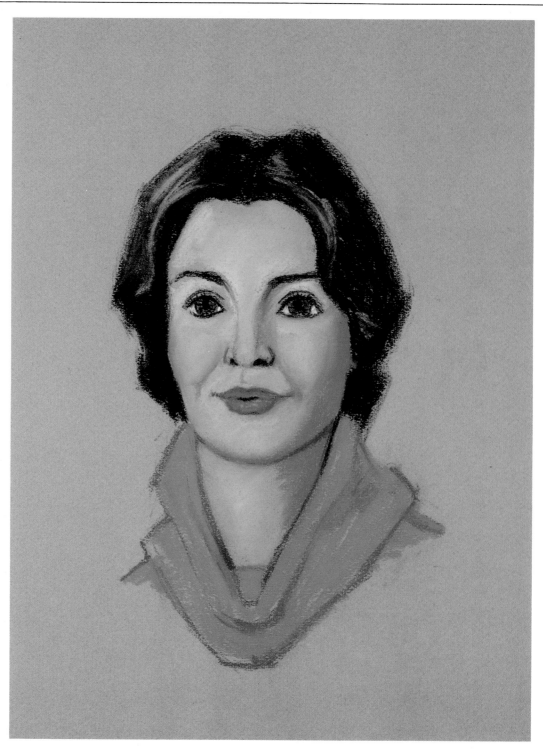

BAD. The average amateur thinks of different items in a painting as very separate units and does not recognize that they must be integrated into the whole while maintaining their own individual identities. The thinking behind this example is that there is one color for the blouse, another for the flesh, and an entirely different one for the hair. But this makes for a rather ordinary rendition.

One way of making your painting more interesting is to use echoes of a dominant color throughout. As you try this, be careful that you don't go overboard to the extent that it becomes "corny" and overplayed. Your good sense and taste should ultimately tell you how much exploitation of color is enough. This is the same principle that I mentioned earlier about flesh. Exploit variations, but don't go so far that flesh no longer looks like flesh. Do not confuse color unity, however, with value, which I shall discuss in another Key.

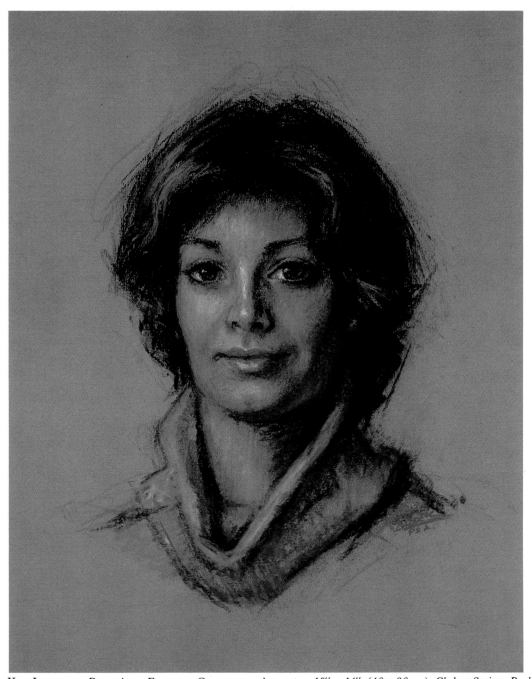

KIM JESMONTH, ROSE ARTS FESTIVAL QUEEN, *pastel on paper, 18″ x 14″ (46 x 36 cm), Chelsea Savings Bank Award, 1976.*

GOOD. A work of art has to have an overall harmony of color. A dominant color should be repeated or echoed in many areas of the painting. This theory is based both on the physical law of reflected light and the artistic feeling for a harmoniously integrated work of art. If you look carefully, you will see evidence of this principle throughout my work, although it is a more abstract principle than some of those I discuss in other Keys. Perhaps it is a personal idiosyncrasy of my technique, but I pass it on to you because it is important to me and I trust it will help you.

In this portrait, notice how I have repeated the cold red of the sweater in the reflected light on the shadow side of the jaw. You can also see a touch of this red around the lower part of the nostril on the shadow side of the nose. Logically, some of this color would be reflected in the underside of the hair—but notice how I have also used it in the lighter areas and around the top edges, where I sought out the structure of the mass as a whole.

As you try introducing a dominant color into your painting, do not worry about what the viewer will think about these artistic embellishments. Most people have rather prosaic minds and will accept this model's hair as being that of a brunette. People who are more sensitive, however, will appreciate what you are doing.

59

Varying the Handling of Different Parts of a Portrait

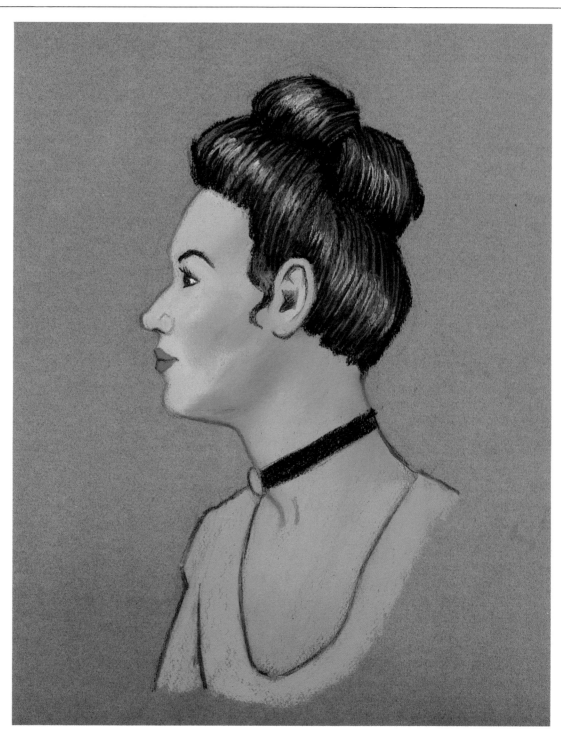

BAD. Sometimes amateurs become obsessed with detail in the wrong places, and this painting is an example of it. The hair here has been greatly overworked, and the portrait looks as though it could have been done for a client who sells hair products or runs a beauty parlor.

This bad example shows other errors I have mentioned elsewhere. Here you can see three distinct color areas—the black hair, the flesh, and the blue dress. These areas are monotonous in hue, and the painting has no overall color unity. Compare this to the good example, where the blue of the dress is repeated on the underside of the jaw and on the neck, as well as in the hair.

Mistakes students commonly make in painting a profile are: making the lips look like a heart turned sideways; not aligning the eye correctly with the indentation between the nose and the forehead; and not placing the ear correctly in relationship to the other features. Compare how the choker on the neck is handled in both examples. In the good example the curvature is drawn correctly, and we see a convincingly round neck.

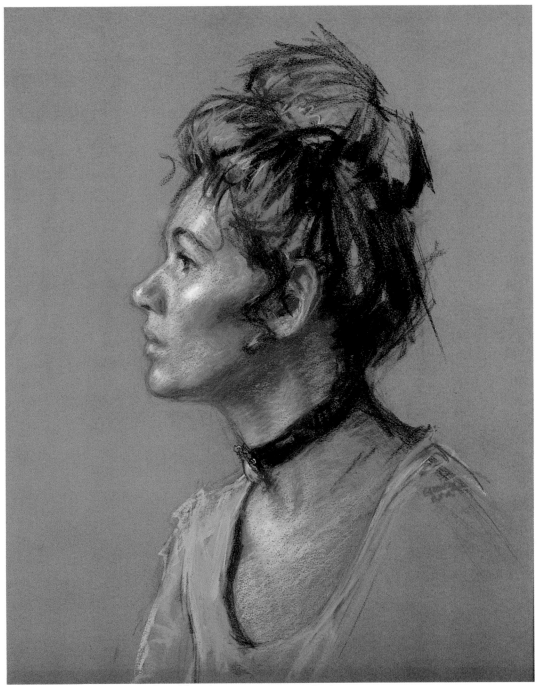

CYNTHIA, *pastel on paper, 22½" x 17", (57 x 43 cm), Private collection.*

GOOD. The artist can vary the amount of contrast and definition in different areas of a painting in order to direct the viewer's attention. When I do a portrait, I usually consider the face and features more important than the clothing and hair style. This probably comes from my having worked as a commercial artist; when I got an assignment, I would ask myself, "What is the reason for this painting, and what is the message that I must get across?"

This particular pastel demonstrates how I often play down a person's hair in order to give more attention to the facial features. I gave a lot of thought and attention to modeling the face here, as you can see. The hair has been executed very freely, yet there is enough detail there for the viewer to "see" the complete coiffure in the mind's eye. Notice how I "felt" the skull under the hair in constructing the head, and the fact that it remains there in the finished work. This illustrates a favorite adage of mine: "Show them how you got there."

Of course, you have to be a good technician to vary the handling according to how much refinement each section requires. This is what I mean when I say *you* should control the painting, instead of letting the painting control you.

15. THE KEY TO
Refraining from Overworking the Clothing

BAD. This example shows too much concern with detail in an item of clothing—and not enough with the artistic possibilities of its color. There is far too much detail in the headband, which is stiff and overworked, and so it commands as much attention as the features. This picture also exemplifies the way students work hard on drawing an area exactly and then hesitate to bring the color of adjacent passages up against it for fear of losing the definition they have worked so diligently to achieve.

GOOD. The section reproduced here is approximately a 6″ (15 cm) square of the original pastel. Even though I refrained from rendering tightly, you can see that there is much more detail in the eyes and nose than in the headband. You can just feel how spontaneously I applied color in the headband—I was not concerned with describing the object but rather with the lovely color passages. Notice the daring use of color in the hair, as well as the way black was used for solidity on the shadow side.

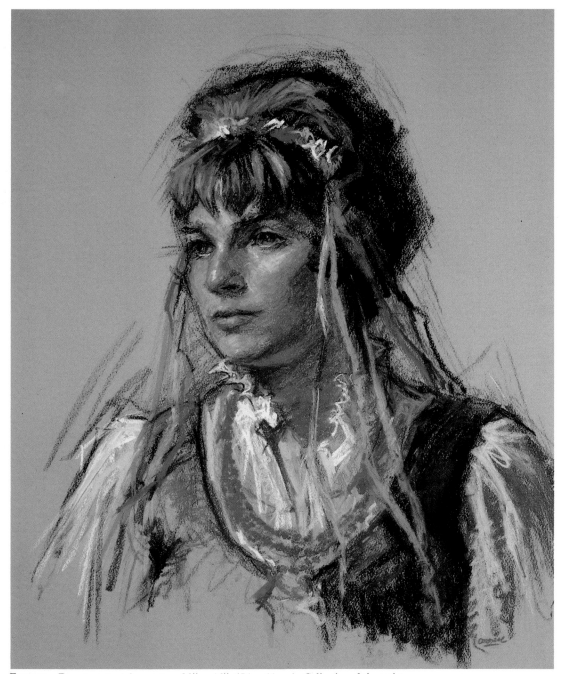

FESTIVAL DANCER, *pastel on paper, 20" x 16" (51 x 41 cm), Collection of the artist.*

GOOD. The subject of this Key is closely related to that of the last one, inasmuch as it deals with your decisions on how much detail and attention should be given to various parts of a painting.

This young woman posed in a wonderful Polish costume that was a family heirloom. It would have been very easy for me to become overzealous about working up all the fascinating detail of this elaborate outfit. As usual, however, I felt that the person was more important than the costume she wore. All these decisions must be made before work on a portrait is begun so that you will know how far to develop each section. Of course, in order to

exercise your options about different degrees of refinement, somewhere along the line you must become a good technician. I keep driving this point home to you every chance I get.

If you study this pastel closely, I think you can feel the zest and enthusiasm with which I executed it. I am pleased that in so many instances I can show you both the work as a whole and close-ups of different sections so you can study in detail just how I handled them.

This pastel shows you once again how I repeat a dominant color—in this case, the cold red can be found in the ribbons, the vest, and in the lights of the model's hair.

Using a Technique That Suits Your Subject

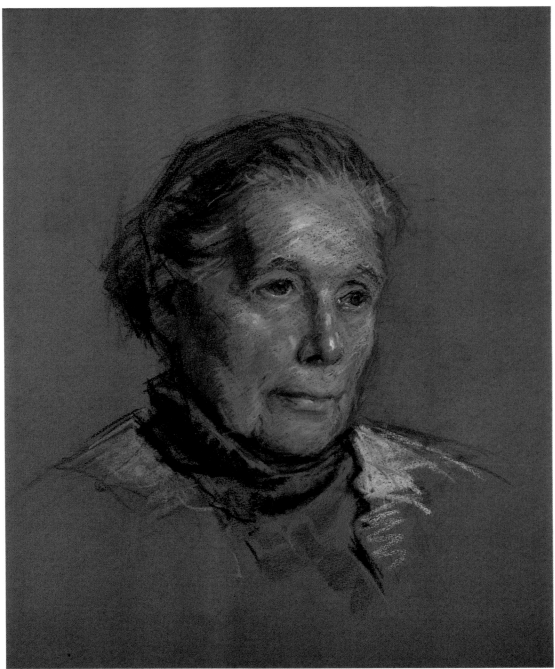

REVERIE, *pastel on paper, 17" x 14" (43 x 36 cm), Collection of the artist.*

GOOD. In this Key, I am departing from my usual format and, instead of using one bad and one good example, I am using two finished examples that are both good but are handled differently. Previously I discussed my philosophy of varying the way I handle different sections of a particular portrait, but in this Key, I want to demonstrate how the subject matter itself influences the way I render the whole portrait. It is quite obvious that a Chopin sonata should be played much differently than a Sousa march. Both may be great music, but they are extremely different in style and form. Here, I am showing you two pastels of entirely different personalities.

The woman in this portrait was a student of mine. She had such a marvelous face that I just had to make this study for myself. It's the type of thing one likes to do, not for any monetary rewards but for the sheer joy of doing it.

Study closely the free, bold way I handled the strong modeling of her head. I found many variations in color and value but spent little time in refining subtle gradations between them.

Notice also the differences in the way I handled the ear and the eyes. The hair flows up from the scalp softly, but the viewer's mind provides most of the detail. This pastel also shows how clothing can be casually suggested.

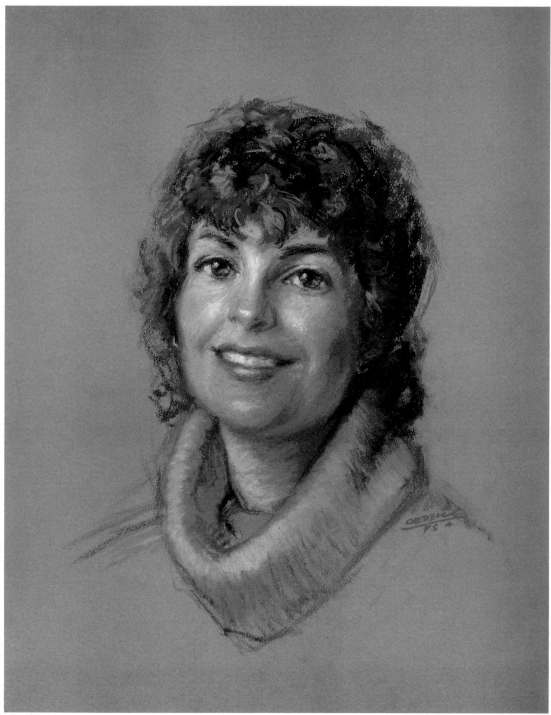

MRS. CARL TRAHAN, *pastel on paper, 18" x 14" (46 x 36 cm), Collection of Mr. and Mrs. Carl Trahan.*

GOOD. This portrait of a lovely young lady was commissioned by her husband as a Christmas present, and the subject matter governed my approach to its execution.

I often think that youth and beauty are the hardest things to do. This woman had a pleasant, charming personality, and I decided to show this by doing a smiling version of her. I have already discussed the fact that a smiling face is not the easiest one to interpret. Study the handling of the mouth closely, and notice how the lips are

modeled; they look round and full, and the teeth are subtly suggested. Also notice that I have used flatter, more frontal lighting on the model to soften and simplify her features.

Even though this is an example of a more refined execution, it is by no means hard or stiff, and the treatment of the hair and blouse are suggested more loosely than the face itself. Notice that the color of the blouse influences the entire portrait.

17. THE KEY TO
Using Lighting Strategically

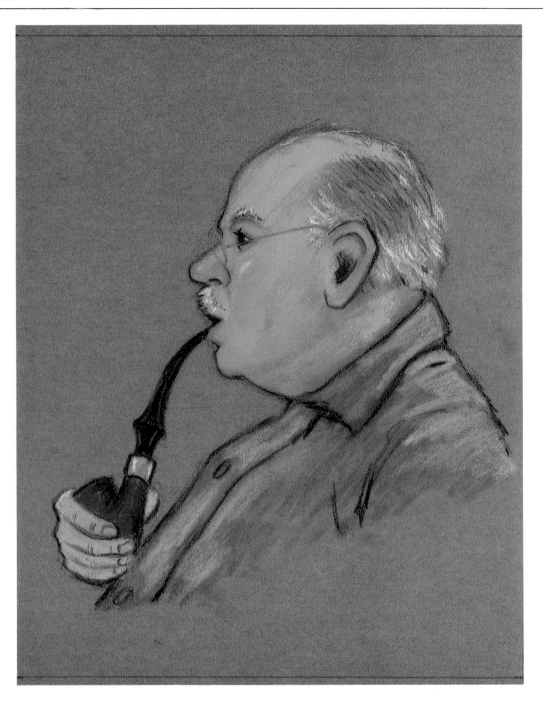

BAD. In this example, you can see how the conflicting lights give the back of the head as much importance as the features. Because of the overall lighting, the portrait has lost its artistic conception and drama, as you can see by comparing it to the good example.

I realize that you may have to work in quarters that are not adequate. I did not always have my present studio. But an inadequate studio just means you have to be more ingenious. If you have to work under artificial light, you must find a way to illuminate the room and your canvas without casting conflicting lights on the model. One way to keep the general lighting off the model is to rig up baffles with screens or pieces of cardboard.

To illuminate the model, you can use a portable photo light. It can be adjusted easily to different heights and angles, allowing you to selectively focus a single light source on the model. The intensity of the light can be controlled by changing the wattage of bulb you use. I like to use a warm incandescent light on the model, but I don't let this light fall on my canvas, for it would cause my colors to look cold when they were viewed in daylight.

In my present studio, there is a bay window on the wall opposite my large north windows, but I have a lined drape that pulls across and shuts off this source of light when I am painting.

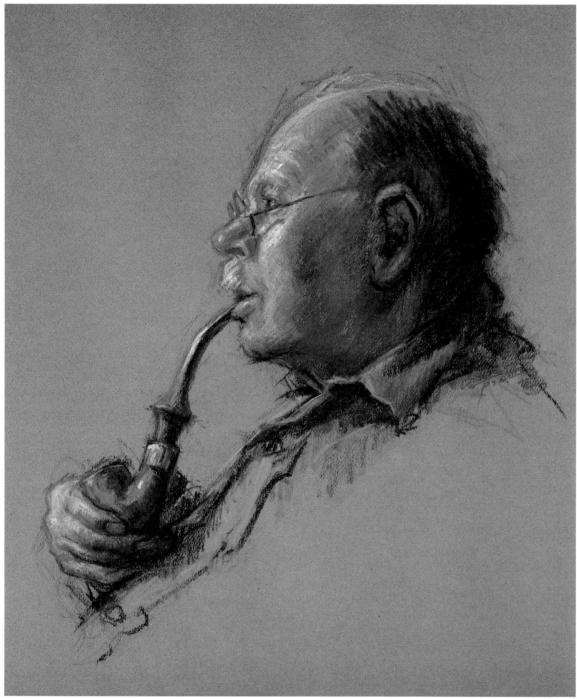

CONTENTMENT, *pastel on paper, 21″ x 17″ (53 x 43 cm), Private collection.*

GOOD. This study of a dear old friend of mine shows my personal preference for a single source of illumination on the model. I like the beautiful simplicity and drama, and the wonderful feeling of form, that a single light source creates. If you have read my books on landscape painting, you realize how much importance I place on lighting. It is just as important in portraiture, but the correct illumination is largely a matter of personal choice—there are no hard and fast rules about it.

Lighting is usually the least interesting when it is "flat" and shines on the subject from the same angle as your viewing angle. Naturally, lighting the model from only a slight angle will cast fewer shadows on the face. In this portrait, I decided to illuminate the model from the side, to bring out his wonderful profile. By throwing the side and rear of his head into shadow, I subordinated those areas to the features, which I felt were more important. Selecting the most appropriate lighting for the subject helps to make a portrait much more appealing.

Exploiting Unusual Lighting Effects

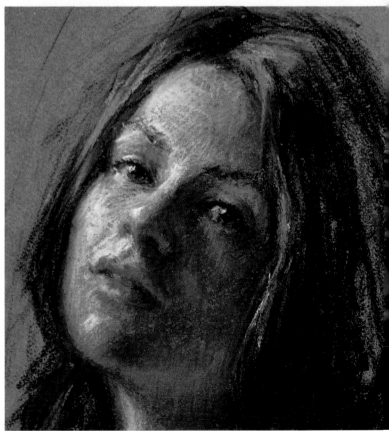

BAD. This study shows how a student unable to observe the subtleties of lighting might revert to a simple and not very interesting solution to depicting the face. Here, there is too much concern with showing a pretty young girl and not enough with the effects of light falling upon her face. Compare the hard edges of this portrait with the artistic softness of the good example; also notice the tendency to make the features too level (I discussed this in an earlier Key).

GOOD. In this close-up, you can study more closely the differences in the way the two sides of the face are illuminated. The left side is in ordinary top light, but notice how this is completely reversed on the right side, where the undersides of the features are the lightest. See how the value of the upper lip changes completely from one side to the other: on the left side, it is dark next to the lighted top planes, and on the right, it is light against dark.

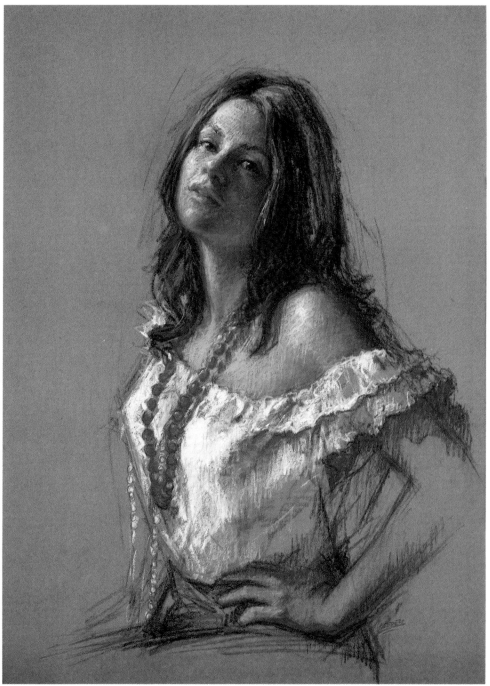

PAULA, *pastel on paper, 29″ x 20″ (73 x 51 cm), Collection of the artist.*

GOOD. I have often remarked that everything I want to tell you is already self-evident in the artwork itself, if you could only "read" it. Most of the time, however, my students can't see an idea until I point it out to them. The lighting on the face of this girl is unusual, but I wonder if you would have been aware of it if I had not called your attention to it.

The main source of light is hitting the subject at a 45-degree angle from the left. It illuminates the left side of the face, but did you notice that all the modeling on the *right* side of the face is created by the light coming from below?

It's the light reflected from her blouse and shoulders. These unusual situations do not happen all the time, but when they do, learn to take advantage of them, for they will give you a slightly different approach to your interpretation of the subject. You don't want to always rely on tried-and-true solutions. Learn to look for the unusual and exploit it. But to be very candid with you, if you are experimenting with an off-beat approach for the first time, it is better to try it on one of your own projects rather than on a commissioned formal portrait.

19. THE KEY TO
Drawing the Head in an Unusual Position

BAD. This example shows how many students render the head when it is in an unusual pose. They tend to draw the features the way they are accustomed to seeing them, but when they are done, they ask, "Why doesn't my portrait look as though the model's head is tipped back"? There is something about us that refuses to accept seeing things a bit differently from the way we think they should be—but unless you learn to overcome this tendency, you will continue to portray the face inaccurately.

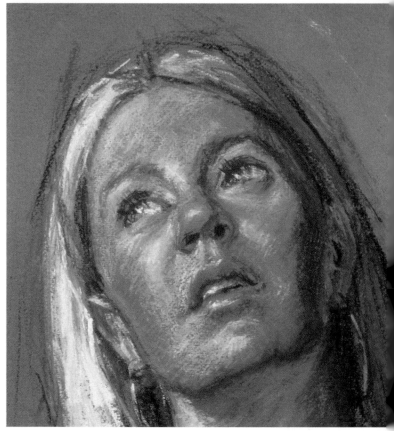

GOOD. Everyone knows that the top of the ball of this young woman's nose would not usually line up with the bottom of her eyes—nor the top of her ears align with the bottom of her nose. But when she tips her head back, as you see in this close-up, it actually does happen. When things like this occur, don't give in to the inner voice that says, "If I draw it like that, it won't look right."

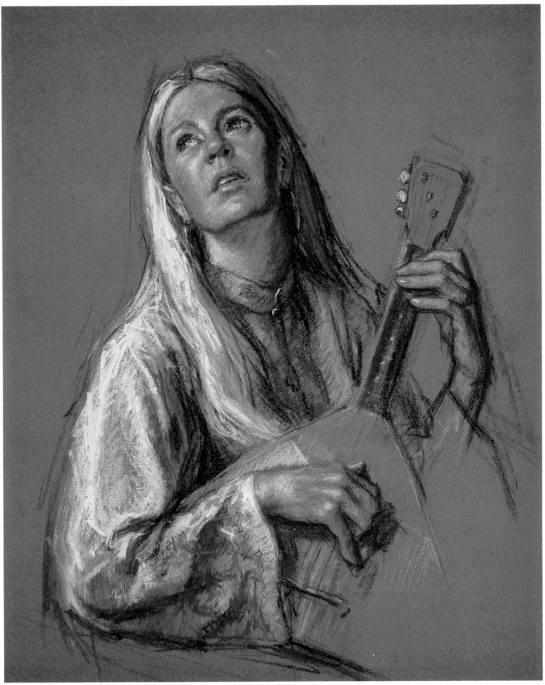

SANDRIKA, *pastel on paper, 26″ x 20″ (66 x 51 cm), Collection of Mrs. Foster Caddell.*

GOOD. In this Key, I am trying to make you aware of a type of mistake that I refer to often: the kind that occurs when the amateur is faced with an unusual set of circumstances, subconsciously refuses to accept the way the subject actually looks, and instead depicts the subject as it "should" appear. Elsewhere in this book, and in my books on landscape painting, I have explained how this happens where color and value are concerned. This Key returns to the basic, all-important principle of good drawing, and I cannot emphasize enough how important this is. As your painting skill improves, any lack of drawing ability be-

comes more conspicuous. To overcome this, students must go back and practice doing more drawing and less "picture making." In the close-up on the opposite page, I point out to you the importance of drawing the face properly, but here I want you to notice also the drawing of the hands, which have importance in relation to the entire pose. The compositional line comes down from the model's face and through her hair and shoulder to the elbow, and then with a sweeping S curve it flows upward from her right hand to where her left hand rests on the neck of the balalaika, and finally, back to her face again.

Painting Eyeglasses That Fit on the Face

BAD. Here the glasses are just painted on top of the model's face; there is no indication that they have form and dimension. There are many mistakes in the head itself, but it is modeled with a bit more solidity than the glasses. There is no suggestion here that the same light that hits the face also falls on the glasses. If there were, some sections of the glasses would appear lighter and there would be cast shadows on the face from the frames.

GOOD. To paint glasses correctly, you must think of them as a solid object affixed to another solid object, the head. The key to painting anything convincingly is studying the effects of light upon it. Do the eyeglasses exist as a light value against a darker one, or as a dark against light? Also study the subtle cast shadows they create. Observe how the values in the eyes are often affected by the lenses in front of them. And finally, look for reflections in the lenses that help convey the illusion of glass, as you see in this example.

THE HONORABLE LEONARD P. MOORE, JUDGE, U.S. COURT OF APPEALS, NEW YORK, *oil on canvas, 36" x 30" (91 x 76 cm), Collection of Judge and Mrs. L. P. Moore.*

GOOD. Many of us have to wear glasses. While they don't necessarily improve anyone's appearance, many people whom we are accustomed to seeing with glasses would not look right without them. The idea of painting glasses bothers many amateurs, but with enough practice in still life painting, you should be able to handle them just as you would any other object—for it is just a matter of painting what you see.

Many times I engage my model in conversation in order to keep his or her expression animated and pleasant. While painting the glasses on this distinguished gentleman, I remarked that I was finding many interesting col-

ors in them—reflections of the sky and trees outside my studio window. He pondered this, and when he mused, "Perhaps you should pretend that all those colors aren't there," I could see he was concerned that in my enthusiasm to see colors I might end up giving him a pair of psychedelic glasses! The colors *are* there, but they are handled so subtly that they make the lenses look more convincing without obscuring the eyes behind them.

Glasses should not be added on *after* the face is done, but rather constructed as you go along. The close-up on the opposite page will enable you to study my handling of the glasses in greater detail.

21. THE KEY TO
Realizing the Purpose of the Portrait

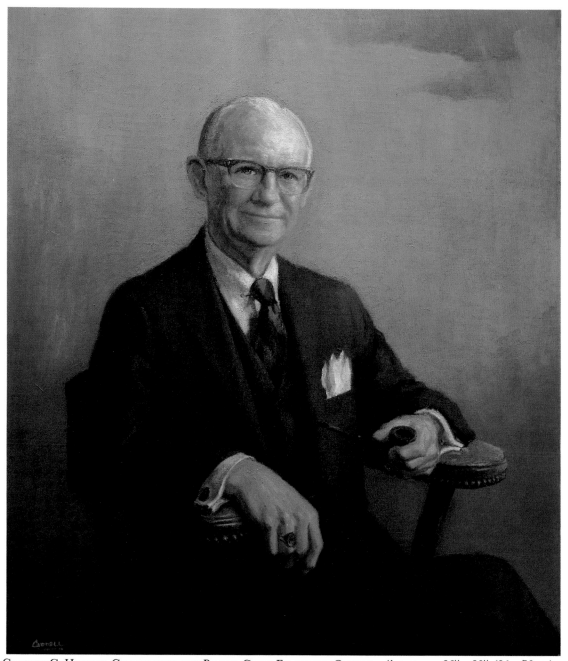

CHARLES C. HORTON, CHAIRMAN OF THE BOARD, CHIEF EXECUTIVE OFFICER, *oil on canvas, 36" x 30" (91 x 76 cm),* *Collection of Old Colony Cooperative Bank, Providence, Rhode Island.*

GOOD. In this Key I again depart from my usual format and compare two finished paintings to demonstrate a very basic and important point: when you do a portrait, you must realize *why* you are making the painting. The example on this page is a typical commissioned portrait of a bank executive. The purpose of such a painting is to enhance and commemorate the individual for posterity. In this case, I even posed the man seated in one of the chairs from the bank so that the portrait would be more personal. The choice of clothing was his, and because he was a constant pipe smoker, I included his pipe in the painting. I handled the background in such a way that it would

focus attention on the man's face first. When you accept an assignment of this nature, you must remember that you have been commissioned to show what an important and successful person your subject is. Some students are unable to take such a pragmatic attitude when they come out of art school, and because of this they should not get involved in doing commissioned portraits regardless of their technical ability. With misguided snobbery, many people also look down on artists who do illustration, but I have found it to be excellent training for pleasing a portrait client with your endeavors.

74

SUMMER OF '72, *oil on canvas, 40″ x 30″ (102 x 76 cm), Collection of the artist.*

GOOD. In contrast to the commissioned portrait, this painting was made just for myself. In doing this type of painting, you can express your idea without having to satisfy anyone but yourself—but of course, you have to wait for someone to like and appreciate it as much as you do before it results in a sale.

This young woman was a student of mine, but she could have been any one of hundreds of young girls at that time. When I painted this portrait around 1972, the model represented to me the new, casual freedom of the younger generation. (I am old enough to remember that even Cecil B. De Mille, the great movie director, couldn't show a bare navel without a "jewel" in it.) My interest in this subject was in the *total* figure. Whereas the most important part of the painting opposite is the man's face, here I cast the face mostly in shadow and became intrigued instead with the colors created on the flesh by the light coming through the hat brim. In the formal portrait, the suit was played down, but here I spent some time developing the details of the jeans because I felt they were an important part of the total effect I was after. These two examples illustrate two entirely different approaches to making a portrait.

Understanding the Theory of Backgrounds

CAROL, *oil on canvas, 36" x 30" (91 x 76 cm), Private collection.*

GOOD. Deciding what to do with the background in a painting is one of the most bewildering problems for amateurs. They do not understand the part it plays in the overall painting, and therefore they cannot decide what is to be done with it; for beginners, it tends to be a hit-or-miss proposition. This important portion of the painting, however, should not be left to chance; every artist should have a definite philosophy with regard to backgrounds. I like to think of the background as the orchestral accompaniment for the soloist, who is the subject of the painting. The two finished paintings shown in this Key illustrate different but equally successful ways of handling the background.

Although no rules hold absolutely fast and firm, here are my basic thoughts on painting the background. First, it should be a middle value against which both the lights and the darks of the figure will register. Second, because the viewer's eye will be drawn toward areas of sharp contrast, it is important to control the amount of contrast created by background areas adjacent to the figure, so that you can direct the viewer's attention to the most important parts of the painting. In this painting, I wanted the viewer to concentrate on the face, and so I maintained the greatest contrast in this section. In the lower part of this painting, I kept the value of the background closer to those of the clothing to make this section less noticeable.

JUNE, *oil on canvas, 30'' x 25'' (76 x 64 cm), Collection of the artist.*

GOOD. In this painting, the background is still a middle value against which the lights and darks of the figure register. But by not darkening the lower section of the background as I did in the painting opposite, I have given this portion of the portrait more attention. An artist has to decide whether he or she wants the viewer to concentrate on the head or the whole figure. This is an aesthetic decision; I am merely showing you how to direct the viewer's attention once the decision has been made.

Another consideration is color. My backgrounds are usually muted, and I use subtle colors that harmonize or complement the main colors in the figure. Edges are also important. Study the backgrounds used in the paintings throughout this book. Notice that the edges of the figures are soft, creating the illusion of space and air around them. You will have a solid, three-dimensional figure if you pay attention not only to the modeling of the figure but also to the color, values, and the amount of contrast of the adjacent background areas.

As I mentioned in my demonstration, I usually repaint the background when my painting is almost done, for it is then that I can most accurately assess just what purpose the background may serve.

Introducing Details That Express Personality

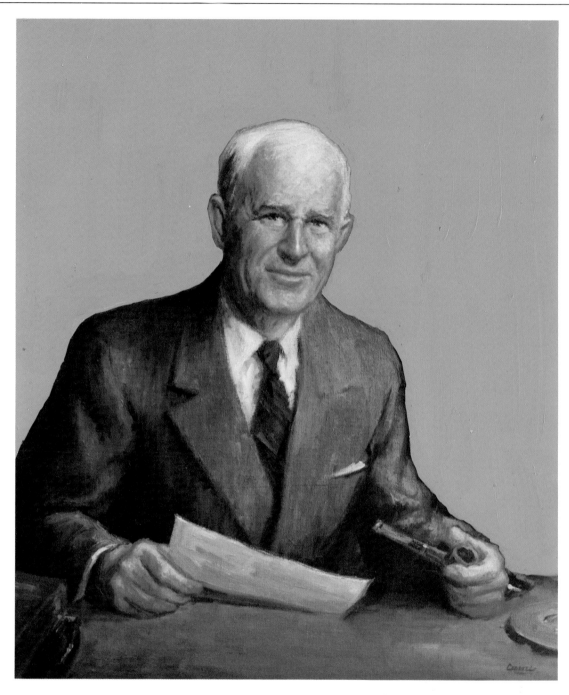

BAD. This example is another version of the painting opposite, but it has been given a plain background. The rendering of the background is too raw in color, its value does nothing to create an artistic conception, and it does nothing to express the personality of the man depicted. It is quite obvious that the background opposite contributes much more to the painting as a whole.

I would like to give you a word of caution, however, about going in the opposite direction and *overdoing* the background. Before starting work on a commissioned portrait such as this one, I usually like to see any other paintings with which my work will hang. When I was commissioned to paint one of the founders of the Mystic Seaport Museum, I was shown a portrait of one of the other founders. I felt the artist had overdone the background, in which he had painted nautical objects that included a full-rigged model ship with every rope and sail executed in the most minute detail. Unfortunately, his handling of the figure was rather stiff also.

Remember that the background should aways play a subordinate part to the figure. If you do add personal items to create more interest, keep your handling of them soft and casual, as shown in the example opposite. Notice how a simple slash of white paint becomes a sailboat "breezing along" in the painting behind the figure.

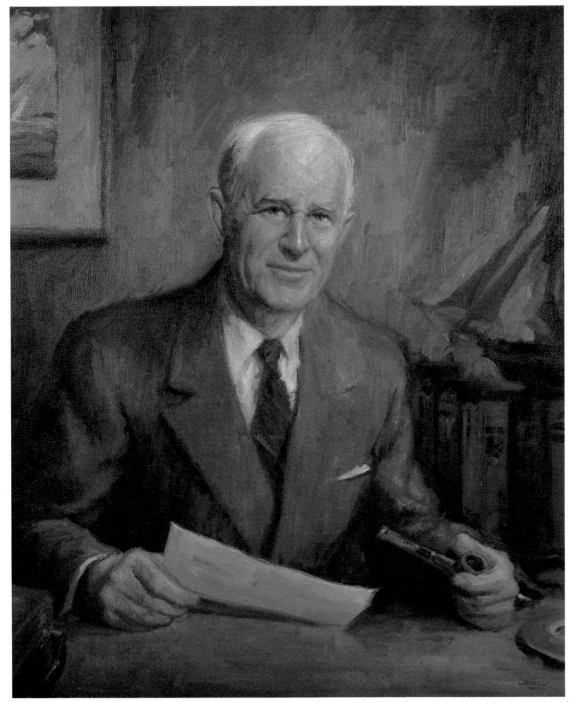

MR. CARL CAMERON CUTLER, *oil on canvas, 30″ x 25″ (76 x 64 cm), Collection of the Mystic Seaport Museum, Inc., Mystic, Connecticut.*

GOOD. A few years ago, when I was commissioned to do this posthumous portrait of one of the founders of the Mystic Seaport Museum, the only visual references I had to go by were one fairly good shot of the man's face and some 35mm slides of him engaged in general activities.

This man was one of America's outstanding maritime historians, particularly of the clipper-ship era. His desire to perpetuate this wonderful part of American history led to the founding of the world-renowned museum.

In this portrait, I tried to show that he was a scholar, an organizer, an author, a collector, and also a very congenial chap. To convey this impression, I posed him behind a desk with his ever-present pipe, and I used props in the background to convey his love of the sea. The bookcase and ship's model on the right were balanced by a painting on the left. While I usually keep the backgrounds of my portraits relatively simple, there is no rule that cannot be broken occasionally, and in this case I felt it was justified. I was careful, however, to subordinate the details of the background to the figure.

24. THE KEY TO
Directing the Viewer's Attention

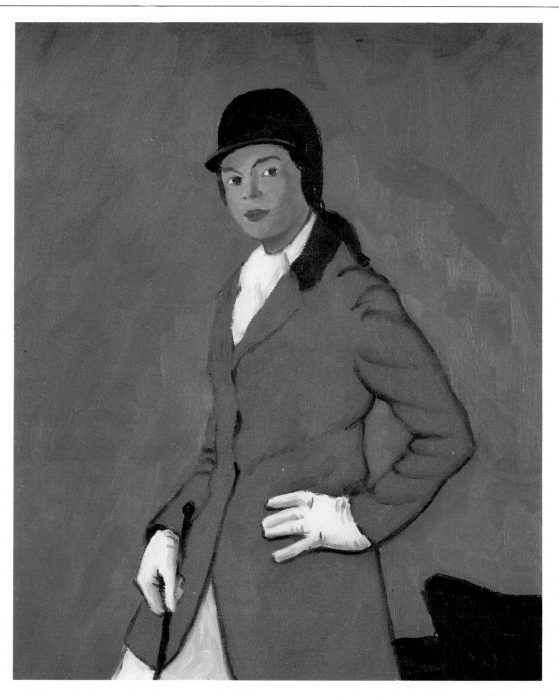

BAD. In this example, you can see what happens when a student fails to incorporate some of the principles I have mentioned in the preceding Keys. Here, the four white areas all have the same intensity, and therefore the sitter's pants demand as much attention as the ascot, which should have the most emphasis in order to direct attention toward the face. The red of the coat is too uniform in value, and the whole work lacks the aesthetic orchestration that you see in the example opposite.

Some additional points. Because in this instance the background value has not been darkened at the bottom, the saddle—which is a subtle statement in the good example—becomes much too important here. In a previous

Key, I mentioned the importance of studying the general tendency of folds when you paint clothing. Here, the folds of the sleeve on the right are harsh and monotonous. In the good example, the folds were selectively designed from the many that took place every time the model posed. I was very conscious of the fact that they should *not* break up the arm area in harsh, repetitious shapes. Very few people will see and appreciate all this thinking in your work, but you need to do it anyway—primarily for yourself and to make your painting a better work of art. I am pointing these things out to make you realize just how much thinking, as well as painting, you must put into your work.

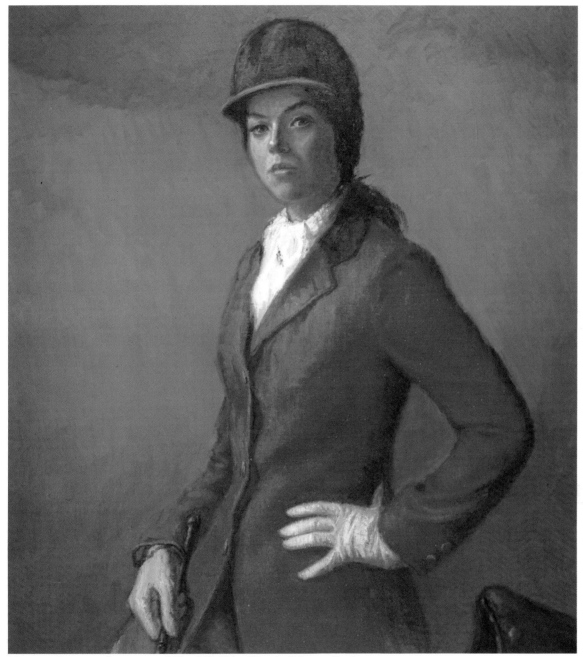

Mistress Debbie, *oil on canvas, 36" x 30" (91 x 76 cm), Private collection.*

GOOD. In this book as well as in my landscape books, I have stressed the importance of determining where you want the viewer to look in your painting and how to go about accomplishing this. I have also stated that if you knew how to study paintings, you could see all this information for yourself in the work and would not need any text to explain it to you.

In a previous Key, I discussed darkening the lower portion of the background as one way to create the greatest tonal climax, or contrast, in the area of the head. In this Key, I show you still another way of accomplishing this. Notice that there are four white areas in the composition—the pants, the two gloves, and the ascot. We can rational-ize that they would actually be rather similar in intensity, but I have modified their values to introduce a subtle crescendo of values that brings the lightest light and darkest dark together in the face area. The "white" pants are actually painted quite gray, the glove on the hand holding the riding crop is slightly lighter, the model's left hand is yet another step lighter, and the ascot is the lightest. See how I have also used this kind of thinking in painting the coat: while the red at the bottom is darker, it becomes progressively lighter and brighter as it nears the face.

Turn the book upside down and see how, unconsciously, you still look at the head.

Achieving a Three-Dimensional Effect with Soft Edges

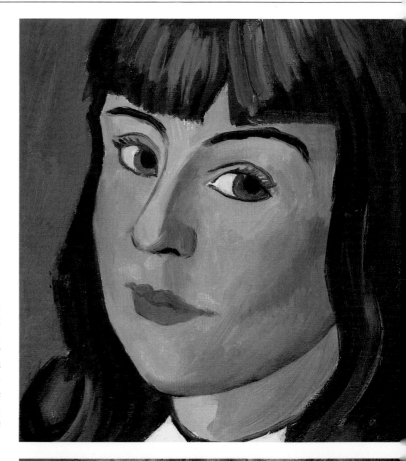

BAD. Hard edges make for a harsh effect that is not artistic. They are created by thinning out the paint too much with medium and by stroking the paint in the same direction as the contours of the figure or object. This approach works fine in lettering but is very bad in painting, as you can see here. Many students feel they *have* to define features, such as the nose, with an outline—when actually the definition of the edge should be hardly discernible, as you see in the good example below.

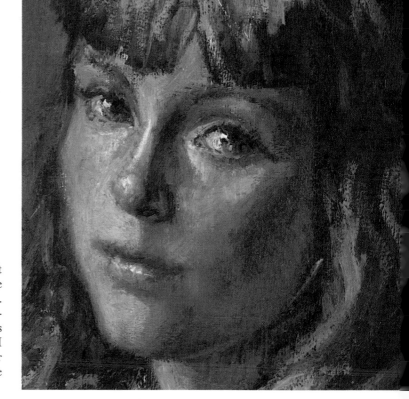

GOOD. In this close-up, I want you to study the soft edges I have used throughout the painting. Notice how subtly the nose and the mouth are defined. When you view the entire painting, opposite, the total rendering appears rather refined, but in this small section you can see that no matter how far I carry an area to a conclusion, I still use broken color and a soft, impressionistic approach in defining the edges.

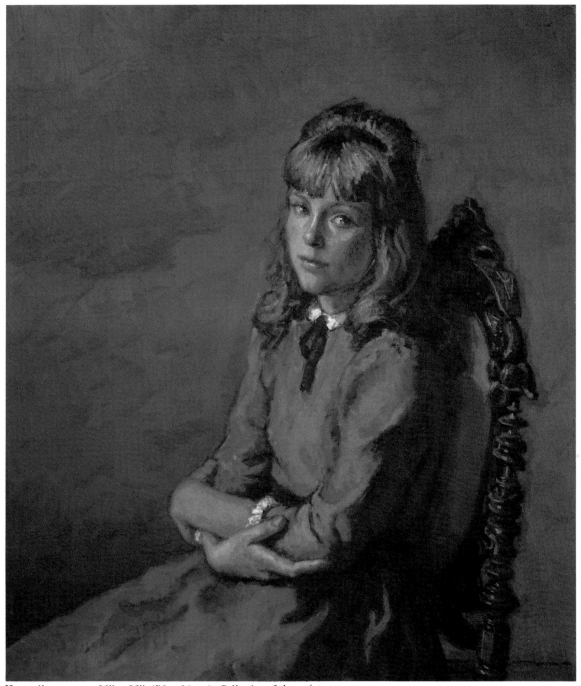

KIM, *oil on canvas, 30″ x 25″ (76 x 64 cm), Collection of the artist.*

GOOD. As you undoubtedly have assumed, I see little merit in the hard-edged type of painting called photorealism. I believe that one of the most important challenges for the artist is taking a flat surface and so manipulating paint on it that the viewer is convinced it has three dimensions, not two. Humans have depth perception because each eye sees farther around one side of an object than the other one does. When we see an edge, we really see a composite edge.

Painting soft edges on objects is one of the best ways to help create an illusion of solidity and three-dimension-

ality. If the edges are hard, the face—or whatever subject you may be painting—will appear to have been pasted onto the surface of the canvas.

This young girl posed for my class many years ago. When I saw her sitting like this, resting between poses, I decided I had to paint her myself—and this is the result. Before going on to the next Key, I'd like to call your attention to the progression of values that I used in the model's dress to lead the viewer's attention up to the face. This is a point that I mentioned in the previous Key.

Achieving the Illusion of Space

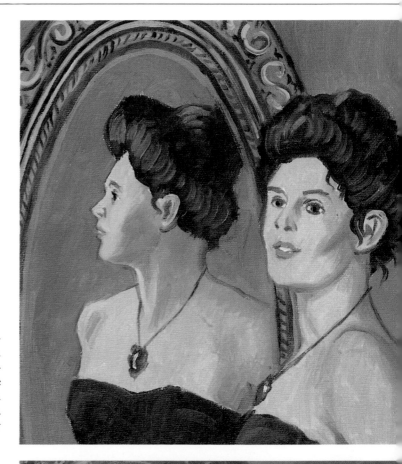

BAD. In this example you can see how the two images fight each other for importance. The reflection has not been subordinated to the actual person because it is just as sharply defined; and because the lights and darks have been stressed equally in both heads, its value range is just as strong. To create a convincing illusion of depth, you must use every means possible.

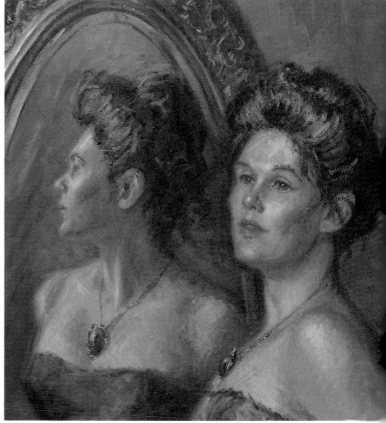

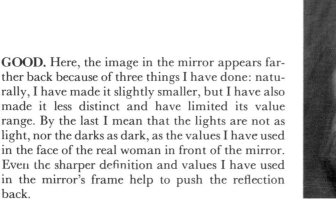

GOOD. Here, the image in the mirror appears farther back because of three things I have done: naturally, I have made it slightly smaller, but I have also made it less distinct and have limited its value range. By the last I mean that the lights are not as light, nor the darks as dark, as the values I have used in the face of the real woman in front of the mirror. Even the sharper definition and values I have used in the mirror's frame help to push the reflection back.

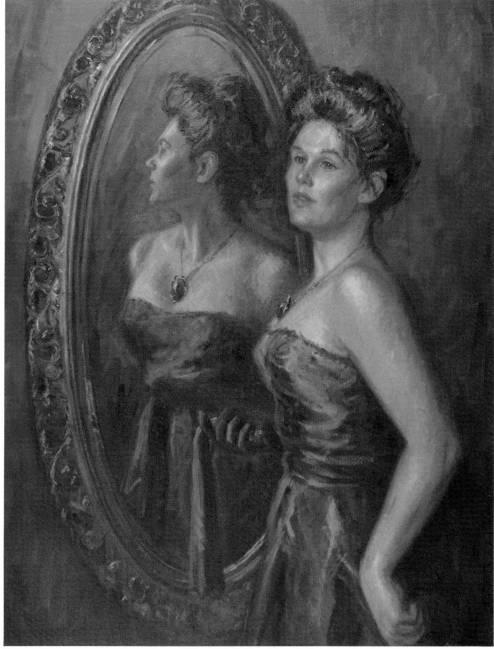

REGAL REFLECTIONS, *oil on canvas, 40″ x 30″ (102 x 76 cm), Private collection.*

GOOD. I deeply regret the passing of elegance from so much of our society, and in this painting, I have tried to show some of that grandeur.

I had long thought it would be interesting to paint a person whose image was reflected in a mirror, and this painting presented a chance to try it. It also posed certain problems, however, for a reflection in a mirror must not compete with the actual person in front of it. Also, it is necessary to paint the distance between the two images, which is really twice the distance from the figure to the surface of the mirror. As the close-up on the opposite page shows, however, I never try to find an easy answer to a painting problem.

The illusion of space is one of the hardest things to create with paint on a flat surface, but if you know the solution to the problem before you start, it is much easier. It is really accomplished in the same ways distance is created in a landscape painting—by softening edges, reducing the sizes of objects, and limiting the value range—but it is done much more subtly in portraiture because the distances are much smaller. Notice that in the portrait on page 83, one hand seems much closer to the picture plane than the other; this is because I applied the same principles I used here in painting the woman and her reflection.

Subordinating Unimportant Details in Hands

BAD. It is very easy to become engrossed on one small segment of a painting and overwork it, as has been done here. If you concentrate hard enough, yes, you *can* see all the lines on each knuckle. The more detail and contrast a section of a painting has, the more it attracts the viewer's attention. The last thing you want in your painting is for many different areas to shout at the viewer. "Look at me, I'm important." When that happens, you have a spotty, "busy" painting.

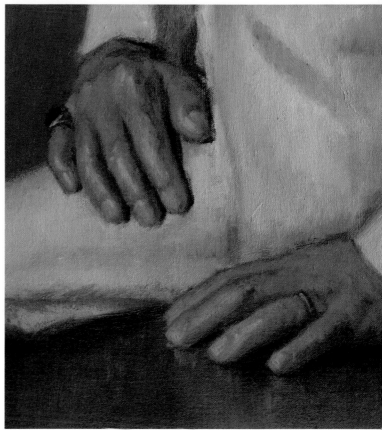

GOOD. No matter how interesting a person's hands are, I feel that most of the time they should be subordinated to the face. One of the best ways to accomplish this is to paint them in less detail than the face. As you are working, stand back, squint your eyes, and look at the model's figure as a whole. Then ask yourself, "How much detail do I see in the hands now?" As you concentrate on refining them in your paintings, remember to give them only that much attention. Notice that the hands in this close-up are handled very simply, without too much detail.

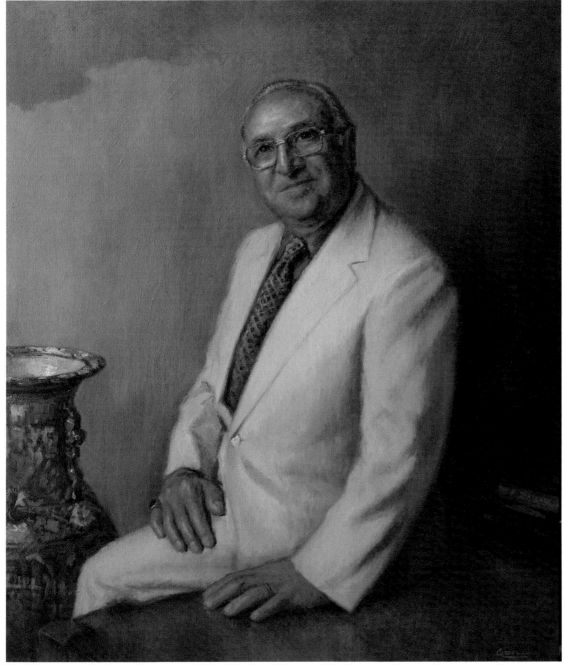

Mr. Vincent J. Scola, *oil on canvas, 36″ x 30″ (91 x 76 cm), Collection of the Vargas Manufacturing Company.*

GOOD. This man was one of three brothers I was asked to paint, and the paintings were to hang together as a group in the board room of one of the largest jewelry manufacturers in America. This painting was to be in the center, and I designed the figure in an upright yet informal pose; the other two portraits were to be seated figures, each facing inward toward the center painting. I convinced this man to be painted in this light suit. It was such a pleasure and change of pace from the dark suits usually worn in commissioned portraits—and it also set off his rugged complexion. The man is a collector of rare oriental objects, and so I included a portion of one of his vases in the composition. This portrait represents a modified approach to introducing personal details in the background (see what I did in Key 23), but notice that I resisted the temptation to overpaint this beautiful object and instead kept it subordinate to the man himself.

As I take up various problems in painting portraits, it may be reassuring to you to know that I made some of these mistakes when I first began painting. I relate to the subject of this Key very well—I still have on my rack a canvas of an old Finnish farmer I had painted, in which I did the very thing I am telling you not to do—I overplayed the hands.

87

Unifying Your Painting with the Correct Values

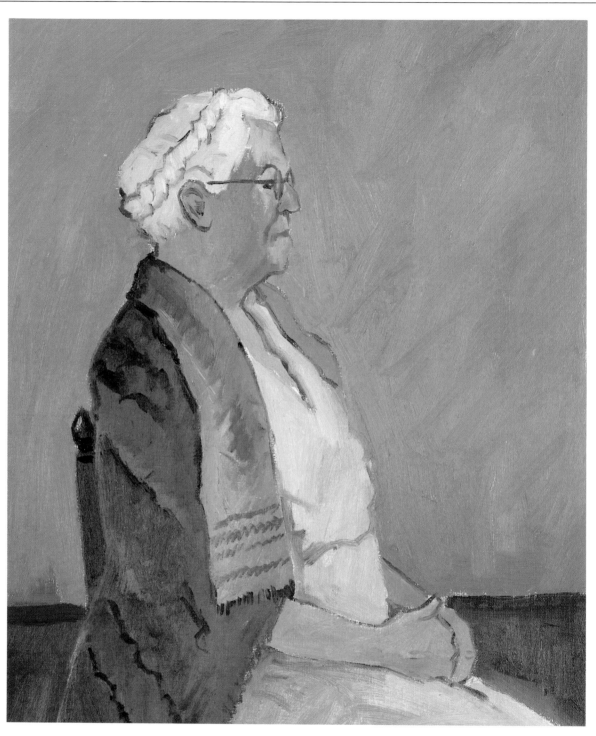

BAD. This painting is spotty and chopped up because too much attention has been given to explaining each and every item in the picture, especially on the shadow side. Learn to overcome this common tendency. The secret is to squint your eyes to study the overall values, and when I say squint, I mean *way down*. In fact, close your eyes and open them just a crack. Then you will see the correct values as they should be painted. Anything you don't see when you squint—even if you do see it when your eyes are open—shouldn't have to be put into your painting. When amateurs don't know this, they usually paint something that resembles this example. It takes a lot of experience to be willing to paint the shadow side of white hair darker than the background, as has been done in the painting opposite. Notice also the intensity of color in the shadow side of the cheek. The average student tends to paint it as you see on this page, explaining, "If I paint it that dark, it won't look like *flesh!*" All this information is right in front of you—I am just trying to make you aware of it and teach you to see it.

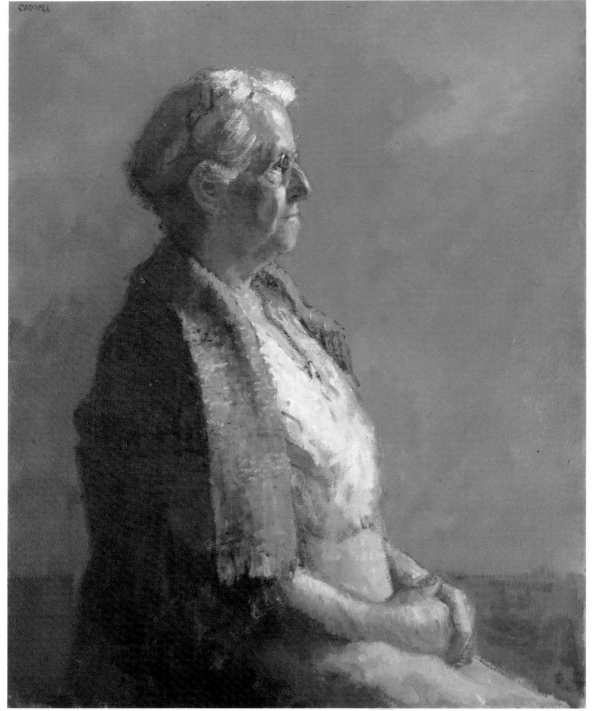

NEW ENGLAND HERITAGE, *oil on canvas, 28″ x 23″ (71 x 58 cm), Collection of the artist.*

GOOD. Often the amateur is overly concerned with fully explaining each item in a painting. This is fine sometimes, but it certainly does not hold true all the time. This figure exists as a good, solid object in space. You feel as though you could walk into the picture, around and behind the lady, and back out again. One of the factors that achieves this is the simplicity and unity of the shadow side of the figure. You sense the separate identity of each item, yet much is lost in mystery. When I am painting, I constantly squint my eyes to study values, and, as often happens, individual items are lost in the shadow mass of the whole. See how little difference there is between the shadow passages of the white hair and those of the neck, or of the shawl, or the chair. Most amateurs "see" too much and feel that they have to explain everything, as demonstrated opposite. In my book on landscape painting, I stressed this same point. The fact that I am taking it up here reaffirms my contention that similar problems exist in *all* painting.

Reverting to Theory When Judging Values

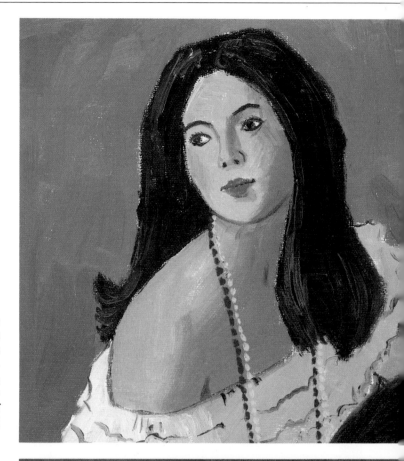

BAD. Here you can see how this subject would be painted by an amateur who could not judge values correctly. I see this happen so often in my classes that I can't stress this point strongly enough. Students just can't seem to bring themselves to paint a shadow sufficiently dark when they subconsciously believe that the object is "light." The shadow side of the flesh and the blouse in this close-up is a typical example of this kind of thinking.

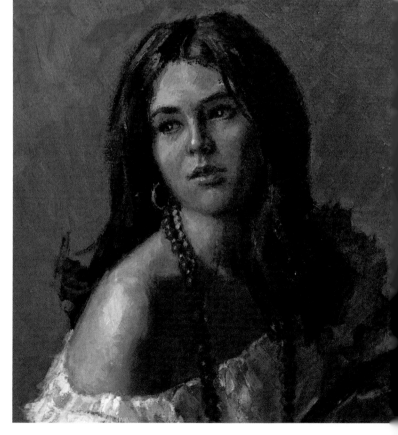

GOOD. The intensity of the illumination on this figure is achieved more by the way the shadows are painted than by the way the lights themselves are handled. To paint the shadows not only in the flesh but also on the shadow side of the white blouse darker than the background takes great courage. Without knowing exactly why, the viewer will feel that there is a great light on the figure because of the correct handling of the shadows. If at first you have trouble "seeing" the values that actually exist, revert to theory in order to know what *has* to take place.

LINDA, *oil on canvas, 36'' x 30'' (91 x 76 cm), Collection of the artist.*

GOOD. In the last Key, I stressed the importance of being able to judge overall values correctly, particularly in the shadow areas, regardless of the color of individual objects. As this is one of the most common mistakes amateurs make, I want to elaborate further on another aspect of the problem in this Key.

I have said elsewhere that ultimately, the answer to your painting problems is a combination of exquisite observation and a knowledge of theory. I don't believe in absolute rules or formulas, but there is one extremely helpful bit of information I can pass on to you: If direct light is falling on the object you are painting, the object is *lighter* than you think it should be. If direct light is *not* shining on it, the object is *darker* than you think it should be.

In this painting, I have combined a figure with a still life study—rather a tour de force with the whole studio reflected in the large bottle. Look closely, and you can see me at the easel. The window is reflected twice, as it is reversed on the opposite side of the bottle. Painting the visual effect of the transparent bottle, showing a combination of the skirt behind it and all the reflections on its surface, was an intriguing challenge. To me, this is what painting is all about—developing the ability to solve harder and harder problems.

30. THE KEY TO
Pulling It All Together

BAD. I want to use this example to demonstrate, once again, many of the common mistakes to watch out for in your work. There is not enough modeling in the face and hair because of the limited value range used. The edges are too hard, defeating any illusion of three-dimensional form. The features are drawn in, not modeled. No effort has been made to find and exploit variations of color in any area. The features are not drawn correctly, and the whites of the eyes are overstated.

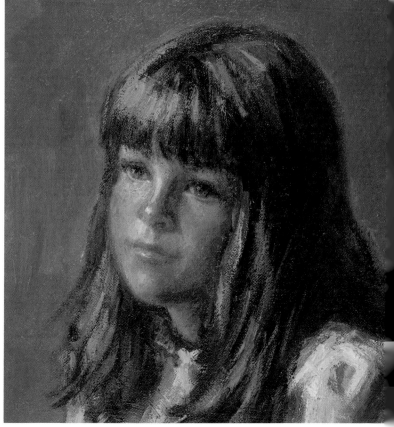

GOOD. Notice the soft handling of the face here, in relation to the spontaneous treatment of the hair and dress. The lights of the hair are lighter than the shadow of the flesh. The alignment of the features is consistent with the tilt of the face. The whites of the eyes are not as white as one might think. The background exists as a harmonious neutral value against which both the lights and the darks in the figure register well, and the soft blending of edges adjacent to the background creates a solid, three-dimensional effect.

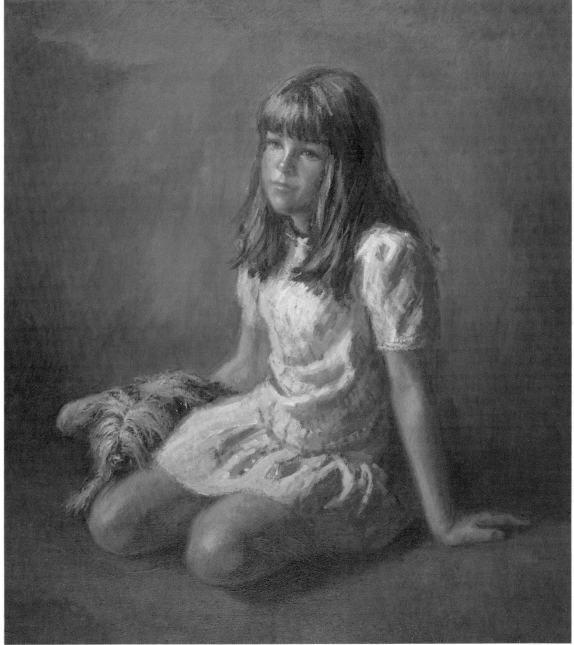

BONNIE, *oil on canvas, 30″ x 25″ (76 x 64 cm), Collection of Mrs. Virginia Harper Mansfield.*

GOOD. My purpose in all the Keys in this book is to pass on to you the knowledge that I find many students lack. I have repeatedly said that a finished work of art will tell you a great deal if you can learn to read it. Eventually you have to be able to analyze your own work as well as that of others. Learn to see where correct thinking has been applied and where it has not.

In this last Key, I want to show you how all of my theory has been incorporated into this painting of a young girl. She exists as a solid figure in space because both the lighter and darker areas of her form register well against the background. Notice how dark the shadow passages of the light dress are, and how light the model's dark

hair is where light falls on it. Also notice all the colors I have used in both these areas. There is an upward progression of the lights in her dress that creates a crescendo toward the face. The knees are nicely modeled, but they are not as bright as the face, even though they are closer to the viewer—for they shouldn't take attention away from the face. Notice the differences in the handling of these two areas (you can study the face more easily in the close-up opposite).

If I have taught you to understand and recognize all these principles, then I trust you will be able to incorporate this thinking into your own work and paint better portraits.

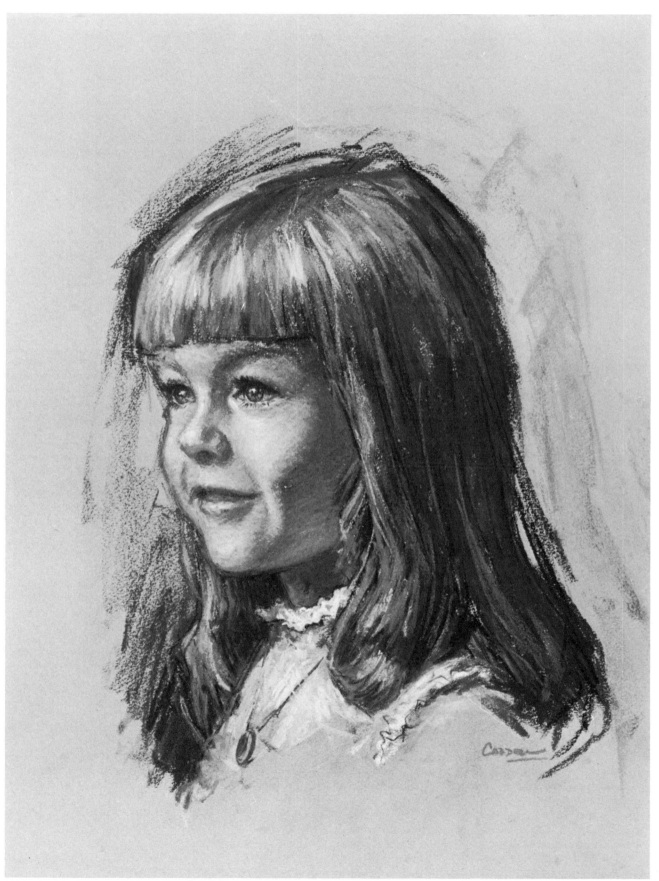

ANN MARIE, *pastel on paper, 16″ x 12″ (41 x 30 cm), Collection of Judge and Mrs. Wilfred Jodoin.*

Special Types of Portraiture

THE COMMISSIONED PORTRAIT

When an artist does a large portrait that contains more of the figure, both the project and the canvas become bigger— and so do the problems. The larger portraits in this book are basically of two types, which are exemplified by the paintings shown in Key 21. One type is the theme, or mood, study in which the particular individual is less important than the total concept of the painting. In such a painting the clothing, background, lighting effects, and other details that contribute to the overall concept may not always be subordinated to the face. These paintings are usually done for my own pleasure, and so I can exercise a great deal of freedom in deciding how I want to interpret my subject. The second type of portrait, which I want to discuss here, is perhaps best exemplified by the typical executive portrait in which every thought and consideration is given to portraying the personality of the sitter. In doing a formal commissioned portrait, the artist encounters so many difficulties in portraying the individual that it is advisable to have already solved the basic problems of how to *paint* long before tacking a project like this.

The first thing I do after receiving a commission is try to find out what the person I am going to paint is like. Usually I do this at an informal meeting with the subject and his or her family, preferably at their home or at a relaxed dinner meeting rather than in my studio. The reason for this is because people are usually more relaxed and more likely to be themselves on their own ground or in a neutral setting. (For some reason, many lay people react to the studio as if they were entering a doctor's or dentist's office—despite my assurances that "I haven't lost a patient yet!")

After the initial session, I have many decisions to make about the entire concept of the painting, depending on the personality of my subject. To cite two extremes, is the person a relaxed country-squire type, or the high-pressure business executive? Will it be best to portray him standing or sitting? Sometimes an additional consideration is the other portraits among which the painting will eventually hang. Usually the commissioned portrait must be rather formal and dignified in its total conception. Many times the subject is wearing an interesting suit at the first interview, but I have learned not to get too enthused about it because most executive want to be portrayed in the usual blue-black or gray business suit. I guess this is why I enjoy doing noncommissioned portraits for myself, when I can have complete control over the entire concept. However, I think my years as an illustrator helped me develop the right philosophy for doing commissioned work. It is necessary to realize it is a commercial assignment and, without compromising one's artistic integrity, please the client with a good, solid painting.

While I recognize my responsibility, the customer also has a responsibility to me: therefore, I have my clients sign a formal contract before the work is begun. This agreement requires that the customer pay one half of the total fee *before* I begin, with the stipulation that if for any reason he or she does not like the finished product, I will keep the painting and the deposit as compensation for my work. I am happy to say this has never happened. All my customers have paid the second half and been delighted with the finished painting. Having such an agreement is a safeguard for the artist, though, and with it the client can never try to insist on unreasonable changes before paying for the work. By having the financial details resolved before starting the portraits, I am free to turn all my attention to the painting itself.

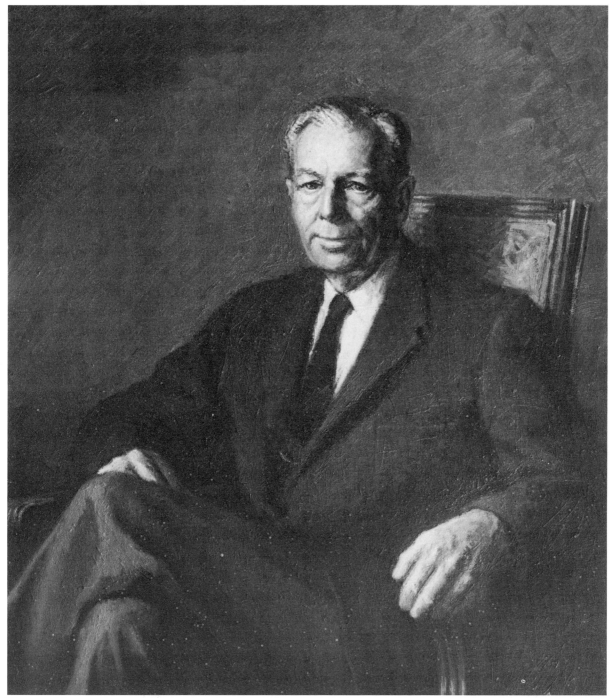

HOWARD MAHAN, EXECUTIVE OFFICER, *oil on canvas, 36" x 30" (91 x 76 cm), Collection of Danielson Federal Savings & Loan Association.*

Many times an executive portrait such as this one is commissioned by a board of directors, and at first the subject enters into the arrangement with almost as much apprehension as if he had an appointment with the dentist. To put the model at ease and give him or her a sense of participation, I explain the whole procedure as we go along. This gentleman was soon enjoying our weekly sessions, and he had a fine, rugged face that I enjoyed painting.

I have mentioned that often people are painted wearing a dark formal suit, but this man came to our first inter-

view in a lovely, subtle handwoven burgundy sport jacket. I suggested that I paint him in this and he congenially agreed. Because his right hand had been injured in a hockey accident years before, I managed to pose him so that most of it was hidden behind his leg. I like to vary the chairs in which my sitters pose, but it is impossible to have on hand all the various chairs I might like to use. Often I ask the sitter to bring to the studio a favorite chair from home. The gentleman in this case had no preference, and so I borrowed a chair from a friend.

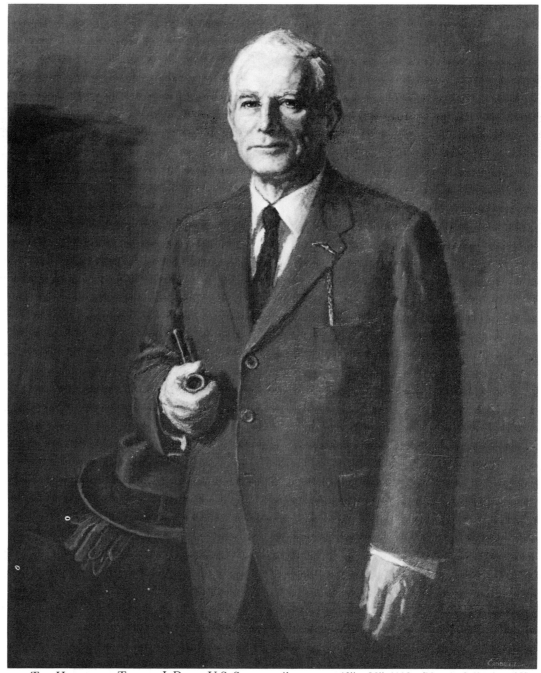

THE HONORABLE THOMAS J. DODD, U.S. SENATE, *oil on canvas, 40" x 30" (102 x 76 cm), Collection of Hon. Christopher J. Dodd, Washington, D.C.*

One of the advantages of being a portrait painter is that it gives you an opportunity to meet many interesting people with whom you might not otherwise come into contact. Often, when I paint someone in a position of importance, I paint the subject from slightly below eye level so that the viewer also must subconsciously look *up* at the person. Usually the model takes a standing pose on the studio floor instead of on the model stand, but Senator Dodd was not a tall man, so I had him stand on a platform about 6" (15 cm) high to give him the necessary elevation.

I also wanted to convey the Senator's friendliness, and so I asked him to pose holding his favorite pipe. I think there is something about a pipe smoker that makes one feel he is a congenial person.

I have discussed with you the thinking that goes into painting backgrounds—mine are usually rather plain, When Senator Dodd came to pose, however, he usually placed his coat, gloves, and old senatorial hat on a chair nearby. One week I asked him to leave them with me so that I could paint them into the background. Adding these articles not only helped the composition but also helped me convey the type of personality the Senator had—that of a dignified gentleman of the old school.

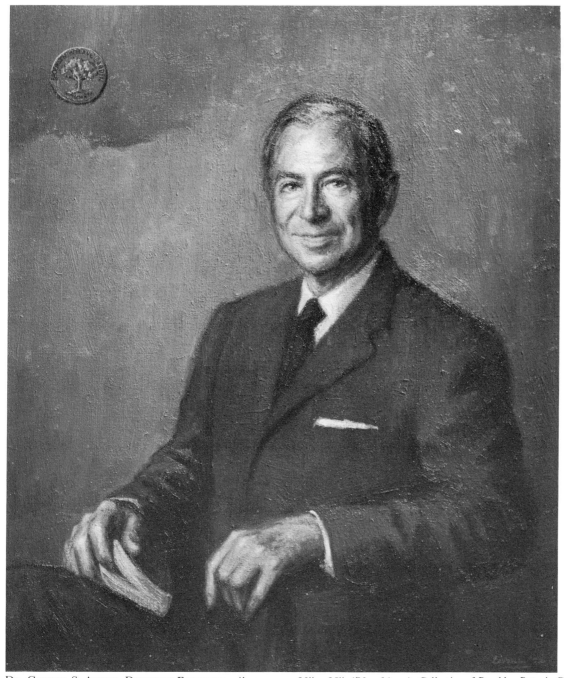

DR. GEORGE S. AVERY, DIRECTOR EMERITUS, *oil on canvas, 30″ x 25″ (76 x 64 cm), Collection of Brooklyn Botanic Garden, New York.*

This model was not only a gentleman, but also, in the literal sense of the word, a gentle man. I tried to convey this refinement in the entire pose, but especially in the hands. He has done much writing, in addition to being a scholar, and so I felt it was appropriate for him to pose holding a book. The medallion in the upper left-hand corner was awarded him for distinguished service, which he modestly suggested I not elaborate on in this text. I had to use a canvas no larger than 30″x25″ (76 x 64 cm) because of space limitations, but I knew that if I designed it well, it would give the impression of being a much larger painting.

I have often remarked that artists work diligently but most of the time receive little direct public acclaim for their efforts. We have all seen singers receive a standing ovation for performing a song that someone else wrote. An artist not only performs but writes the score as well. The unveiling of this portrait, I'm pleased to say, was different. Commissioned by the Women's Auxiliary of the Brooklyn Botanic Garden, it was ceremoniously unveiled in their auditorium, preceded by the striking of a large oriental gong. As the painting was undraped, the audience gave a standing ovation. Receiving this kind of recognition once in a while does one's artistic heart good.

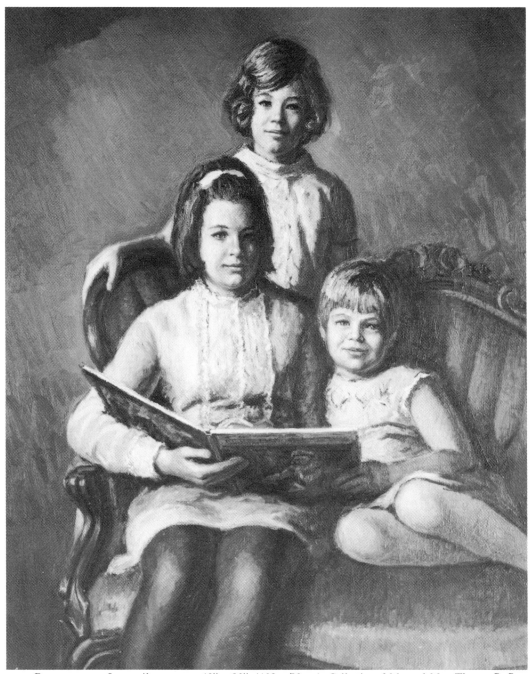

CHRISTINE, PATRICIA, AND LISA, *oil on canvas, 40″ x 30″ (102 x 76 cm), Collection of Mr. and Mrs. Thomas B. Ray.*

The group portrait is always a challenge. I am reminded of the time a woman called me about having a portrait done of her husband. When I quoted her the price, she exclaimed that if she were going to pay that much she would have me put her in it also! Needless to say, when I told her that two people would be twice the price, even if they were within one frame, I never heard from her again!

The mother of these girls was a student of mine, and their grandmother commissioned me to paint them. In toying with compositional ideas, I decided the girls would look good in this kind of arrangement, and so I purchased the love seat especially for this project. I liked the idea of the triangular composition superimposed on the curved, flowing lines of the furniture.

Once the painting was underway, I reverted to having preferably just one, but certainly no more than two, of the girls present at any painting session. No matter how well-behaved children are, they find posing for hours tiresome, and they are apt to get a bit playful if too many personalities are present at one time. When I wrote to the family some years later about the releases necessary for reproducing the painting in this book, they sent me a present-day photo of the three girls posed in the same grouping. I was so pleased with this gesture—and what fine young ladies they are!

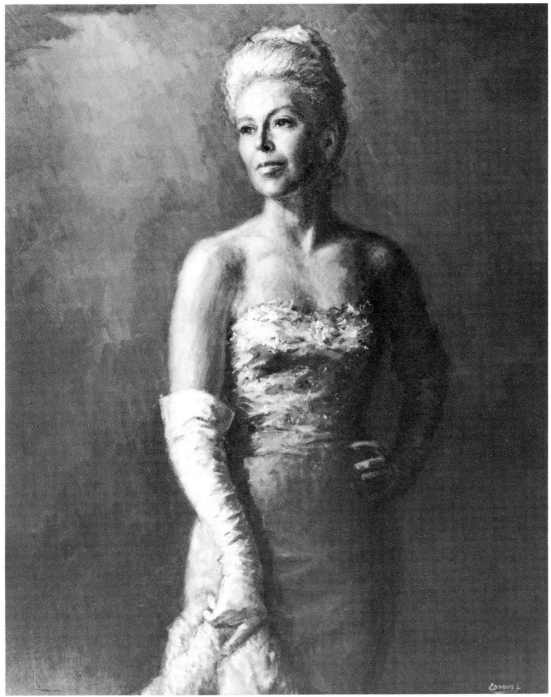

MRS. VIRGINIA HARPER MANSFIELD, *oil on canvas, 40″ x 30″ (102 x 76 cm), Collection of Mrs. V. H. Mansfield.*

In this painting I wanted to depict what you might call regal aristocracy. Notice how I employed the casual treatment of the mink cape, which hangs almost entirely out of the picture. It is the start of a flowing S-curve that leads the viewer's eye up the arm and to the face. The arm is a nicely modeled cylinder, and the round shoulder is a spherical form. The longer I paint, the more conscious I am of these basic forms.

The entire right side of the figure almost melts into the background. The hand on the hip just barely catches a bit of light to give it some modeling.

I handled different areas of the painting in many different ways, as you can see. I have used one approach in the fur and another in the long glove. The dress is smooth at the bottom, but I have used a greater impasto at the top to indicate the lacy overlay. Since the sitter is blond, I asked her to pose in a blue dress; the gloves were off white, and the cape was a pearl gray. All this seemed to dictate a blue-gray background, which I kept rather muted.

Every portrait should convey a particular feeling, and I believe that in this one, I was successful in achieving the mood and personality of the model.

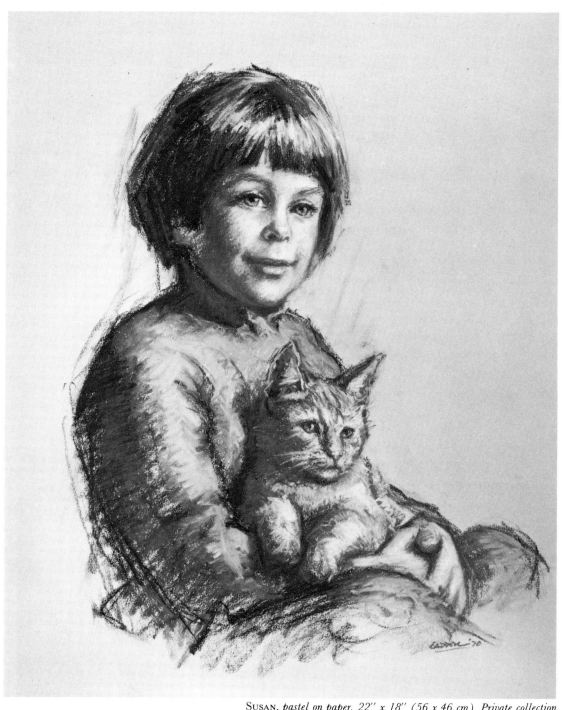

Susan, *pastel on paper, 22″ x 18″ (56 x 46 cm), Private collection.*

A number of years back, I was commissioned to do companion portraits of the two sisters on these pages. Whenever I have a new subject to do, the first questions I ask myself are what is this person like, and how can I best portray this individual? It has always amazed me how different brothers or sisters can be, coming from the same family and environment. It didn't take me long to realize this young lady was the little tomboy of the two. She arrived at the studio in a red jumpsuit, and even though she brought other clothes with her, I decided that she should pose in what she was wearing.

This portrait was a "package" deal—the little girl came

with her cat, "Slother." She even insisted on consulting with the cat to see if he was ready to pose or not. Thank goodness my years of doing children's illustrations had prepared me to cope with almost any situation. They seemed to make a natural pair, she and the cat. My wife had to make all sorts of sounds and perform antics to keep the cat looking in somewhat the same direction. When it was not posing, we secured it in the bathroom, where it proceeded to inspect every square inch!

Notice the rhythmical flow of the design of the figure, and the way I left much of it suggested and went all out on the child's delightful little face.

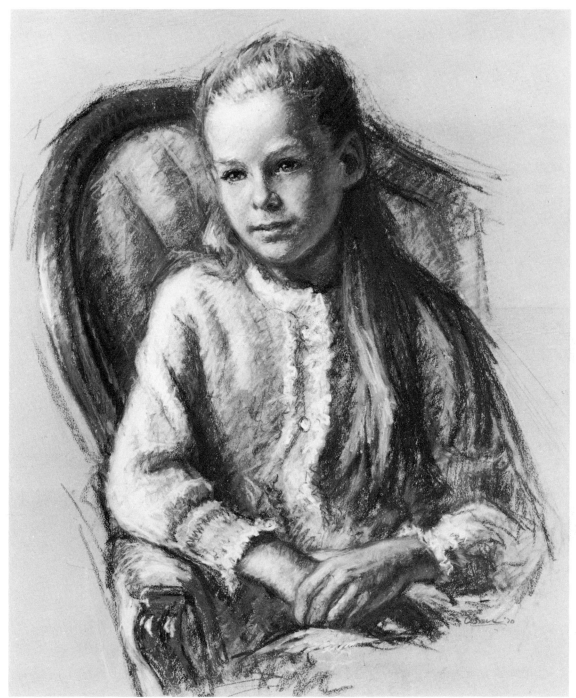

JENNY, *pastel on paper, 22″ x 18″ (56 x 46 cm), Private collection.*

This sister was not only older, but she was also the "young lady" of the pair, and I decided that she should be posed in the corner of the old-fashioned love seat that I had used for the group portrait on page 100. She was a charming model and had done a great deal of posing for photographers.

Notice the free sketchiness of my approach to this portrait. The lines I make as I try to sense the rhythm of the composition are often left in. (Amateurs are usually very careful to erase anything like this.) I spent a great deal of time exploiting the color possibilities in the girl's dress and the love seat. Many times, when a girl has long hair, I let one side hang down and drape the other over her shoulder, as I did here, to avoid repetition of shapes. When I came to the head, I gave a lot of attention not only to her sensitive little features but also, as I stressed in the first Key of this book, to modeling her head solidly. Observe how the head is darker where the form curves away from the illuminated part of the face and moves into the shadow area. The luminosity of the jaw and ear area is created by the reflected lights. Remember what I said in the Keys: a portrait should succeed as artwork even if the viewer doesn't know the identity of the subject.

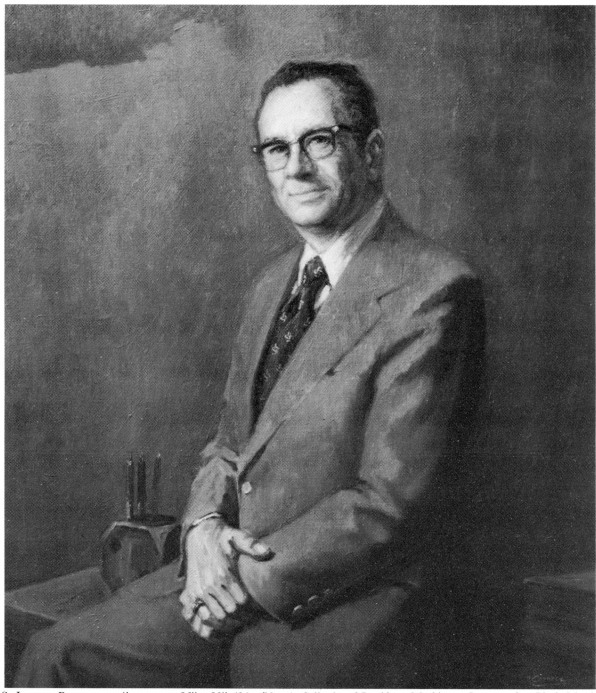

DEANE S. JEAGER, PRESIDENT, *oil on canvas, 36″ x 30″ (91 x 76 cm), Collection of Providence Washington Insurance Co., Rhode Island.*

I did this posthumous portrait for a large insurance company. In a commission such as this one, when you must work from photographs of a deceased person, it is difficult to capture a sense of the person's actual "presence" in the portrait. I think you might be interested in how I did it.

After looking through many photos of the subject, I felt I had a reasonable idea of the type of chap he was. Among the photos of the man's business activities, I was able to find a good three-quarter view of his face, but none of the available material showed his body in a satisfactory pose for a board room painting. I solved the problem by get-

ting a friend to pose for the entire body, but it is no small task to place one person's head on another's body and keep the proportions correct.

I wanted this pose to give the viewer the feeling that the man had just sat on the front edge of his desk to have an informal talk. I'm pleased to say that both the company and the subject's widow were happy with the final result. The widow had helped me add a personal touch by sending me, along with many photos, a special tie she had given her husband, which had a design of intertwined J's. Including details like this means a great deal to people.

THE POSTHUMOUS PORTRAIT

Many portrait artists work from photographs exclusively, and when I did illustrations, many times I was forced to work from photos out of necessity. Because of this training, I am able to work from photos, but ordinarily I feel that the best possible portraits are done directly from the sitter. However, when an artist is asked to do a posthumous portrait, there is little choice but to work from photographs. On one hand, because a portrait done from photographs is apt to be less satisfying aesthetically, I have mixed emotions about doing this sort of work. On the other hand, I see the pleasure and satisfaction it brings the deceased person's loved ones—and sometimes that is satisfaction enough.

Portrait painting in itself is hard enough, but painting the posthumous portrait is even more difficult. First of all, you have never seen the individual, yet you are expected to come up with an interpretation that will please the many people who have lived and worked with the person. (My first reaction is often, why didn't they think of having a portrait painted while the person was still alive?) Sometimes the situation is so sad that you almost feel the client is expecting you to bring the subject back to life. I am often tempted to say, "Please remember, I am not God."

Having agreed to do such a commission, however, your first task is to gather all the photographic material you can possibly assemble. The main problem with photos is often the lighting. Even if there is sufficient detail for you to study the features, many of these photos may have been taken with a flash camera. The flash, of course, creates the most uninteresting, flat illumination, and it does not give the best indication of form in the features. In such instances, your big question is then whether you should try to change the lighting or accept it, knowing it is not the proper lighting you would have used had you been able to pose the model in the studio.

Many times you will not be able to find any single photograph that is good enough to work from as your prime source, but by going over and over a group of photographs, you may be able to form a composite image of the person. When I did the portrait of Carl Cutler in Key 23, I noticed that in many of the family slides he was smoking a pipe. No one commissioning the portrait mentioned this, but I know that any pipe smoker always seems to be giving his pipe attention—he not only smokes it, he also fondles it and cleans it. This gives him something to do with his hands, and it also seems to be a logical solution for the artist who is wondering what to do with the hands in a portrait. The subject will look more natural because of this detail.

When I am commissioned to paint more than just the face, I often find someone who is approximately the same build as the subject to pose for the body. Believe me, it is no simple task to place one person's head on another's body and have the portrait look as though the subject had posed for you himself in the studio!

The photos on pages 107–109 will give you an idea of how I went about one particular commission. The canvas size was to be 30″ x 25″ (76 x 64 cm). This is really too big a canvas for just a head, but it is too small to get much of the figure on it without scaling the figure way down. The subject was a personable and dearly loved pastor of a church near Providence, Rhode Island. The work was commissioned by one of the parishioners, who happened to have been my former high school art teacher. I could find only one good detailed photo of the pastor's face, and that was taken looking down at him as he sat at his desk. When I paint a standing figure, I like to look slightly up at the person. It adds a feeling of nobility and dignity, but in this instance I was not about to try to change the angle from that of the only good photo available.

Many ministers hold the Bible as they preach, and this pose enabled me to expand upon the ecclesiastical theme while solving the problem of how to include more of the figure without leading the viewer's eye out of the picture with the long black robe flowing downward. I am fortunate to have on loan from my dear friend and mentor, Peter Helck, a wonderful old wooden mannequin that was carved in Italy years ago. It is a tremendous help to me. I was able to borrow the minister's robe, which fortunately included the red collar of his doctorate degree. I had my wife take several Polaroid shots of me wearing the robe, posing in different positions and holding the Bible. This helped me with the pose. When it came time to paint the robe, I draped it over the mannequin. This is the same approach that artists used years ago when painting royalty. They could work from the costume on a mannequin, which reduced the amount of time necessary for the important and busy subjects to pose.

When it came to painting the hand, I placed a mirror on one of my easels, and as you see in the photo, I was able to use my own hand for a model—a device I used many times as an illustrator.

This gives you an idea of how I approached just one posthumous portrait. Naturally, there is no single system that can always be applied, for the approach has to be tailored to each individual project. Sometimes the problems tax my ingenuity, but I find my days of doing illustrations were great training for such endeavors.

When a posthumous portrait is done, all you can say is that you've done your best. You will always feel that if you could have seen the person firsthand, you could have done even better. But any misgivings I have ever had about doing this type of portrait are compensated for by the appreciation it brings from the people who did know the person and feel I have done a good job.

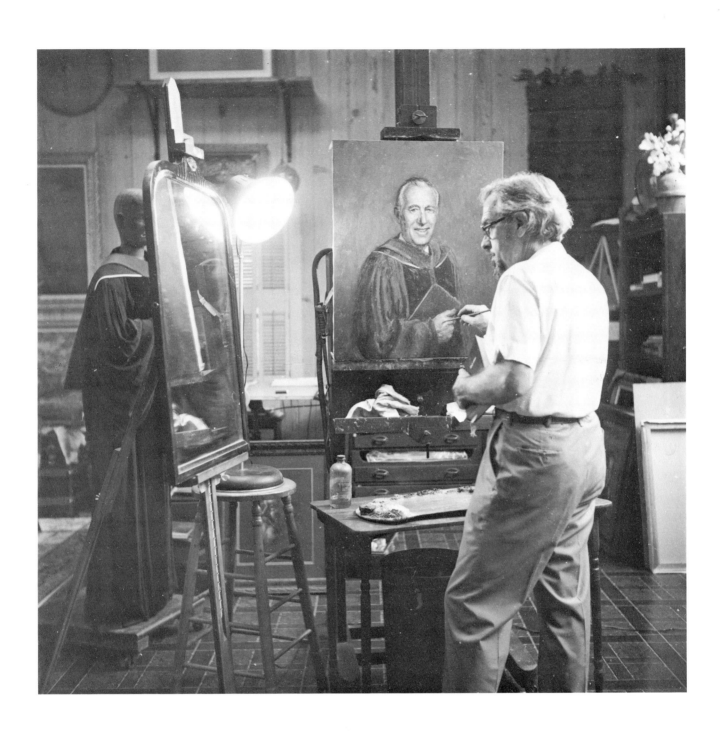

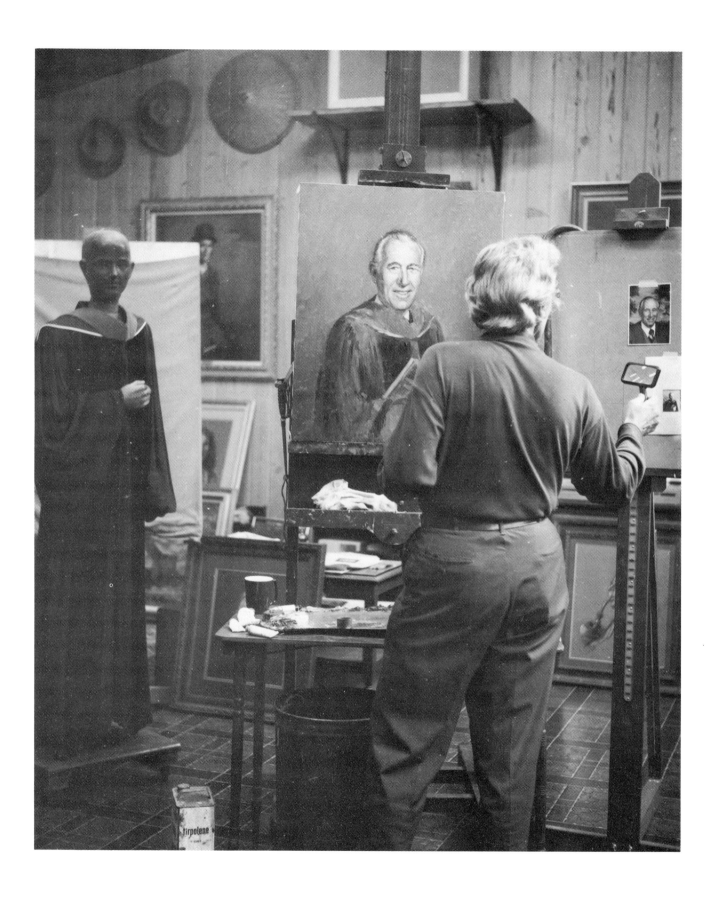

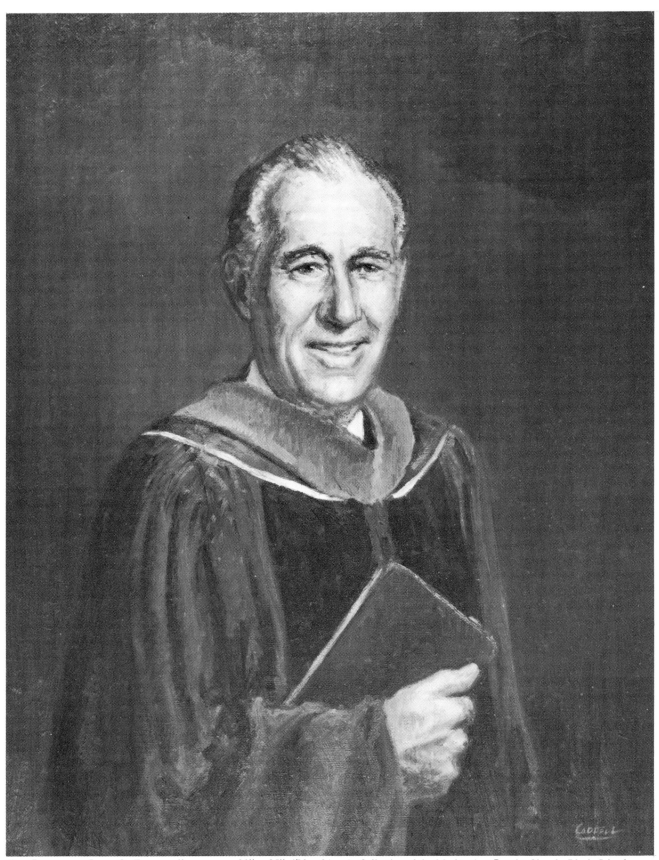

THE REVEREND JOHN C. ZUBER, *oil on canvas, 30″ x 25″ (76 x 64 cm), Collection of the Meshanticut Baptist Church, Rhode Island.*

SELF-PORTRAIT AT AGE TWENTY, *oil on canvas, 26″ x 20″ (66 x 51 cm), Collection of the artist.*

THE SELF-PORTRAIT

All artists seem to be intrigued by the idea of tackling a self-portrait. I first confronted this noble project at the age of twenty, when I was serving an apprenticeship as a lithographic artist and studying painting at night.

Your first problem in doing a self-portrait is that when you look in a mirror, you are seeing yourself reversed. Actually, this is the only *you* that you know, except when you see a photograph of yourself which, to others, "reads right." If you want to see the difference created by seeing a reversed image, have someone you know very well stand next to you, and look at the person's image reflected in a mirror. Your friend may look different to you, but that image is what looks normal to him or her. I can't recall my exact thinking back in those distant days, but this reversal problem must have bothered me because, as you can see, I reversed everything that I saw when looking in the mirror so that it would look "correct" in the painting. Had I painted myself as I saw myself, I would have appeared to be left-handed. I am not showing you this early effort as an example of good painting; however, it was my sincere effort as a struggling young art student, and I think it might be interesting for you to see self-portraits I painted at three different stages of my career. I did not know enough about painting at that time, but I could draw fairly well. Notice how hard the rendering is in the folds of the smock. Unfortunately, no one had cautioned me, as I have done you in this book, to keep the edges soft by going against the direction of the folds with my brush strokes.

My next self-portrait was done twenty years later. By that time, I realized I shouldn't try to reverse what I saw, and so you will notice that the part in the hair is now on the opposite side. By now I had no problems with painting, but when "how to do it" is no longer a problem, "what to do" becomes the most important factor. In normal portraiture, it is quite customary to be complimentary in your interpretation of your subject, especially if you are doing commissioned work. In doing a self-portrait, however, you always have a subconscious feeling that you will appear egotistical if you flatter yourself, and so many times there is the tendency to go the other way. That is what my wife said I did in this second portrait.

When you're doing a noncommissioned work such as a self-portrait, you can always try a different approach, perhaps one that you might hesitate to use if you were painting someone other than yourself. In this case, I tried using a dramatic side light with half the face in shadow. I no longer felt I had to dress and "look" like an artist, as I did in my earlier effort, but when I felt the composition needed something in the lower left, I painted part of a large carved frame that was in my studio. It filled the void and subtly suggested "art."

The third self-portrait was the last piece of work I did in assembling this book. I had known I had to do it for months, but somehow, like the shoemaker whose children have no shoes, I neglected it until I just couldn't procrastinate any longer. When I got the portrait done, I was interested to find the angle of the pose was so close to that of the first one. There is much I could say about this pastel, but perhaps I should just say that this is what I saw when I looked in the mirror after more than a year's hard work preparing this book for you.

Why don't you try painting a self-portrait yourself sometime!

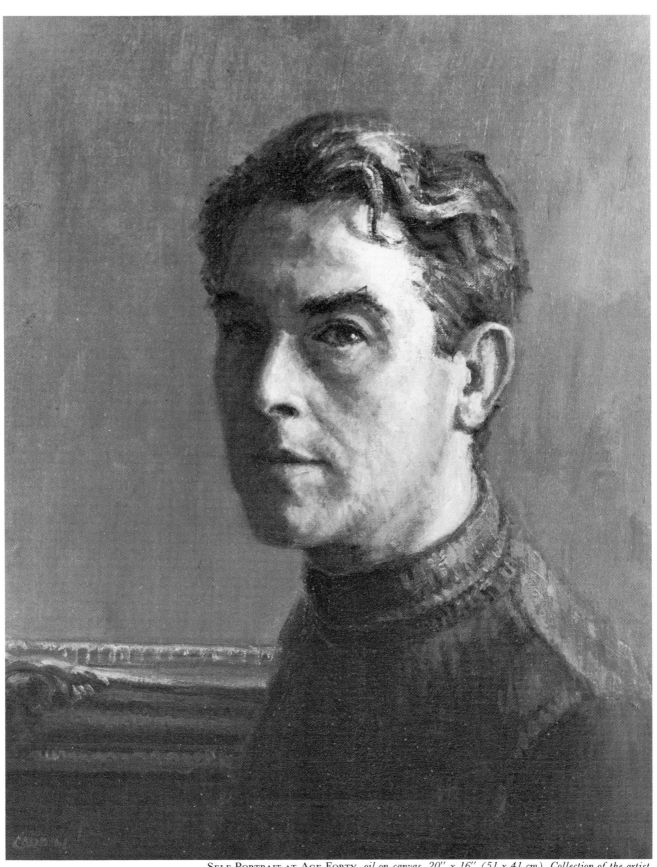

SELF-PORTRAIT AT AGE FORTY, *oil on canvas, 20″ x 16″ (51 x 41 cm), Collection of the artist.*

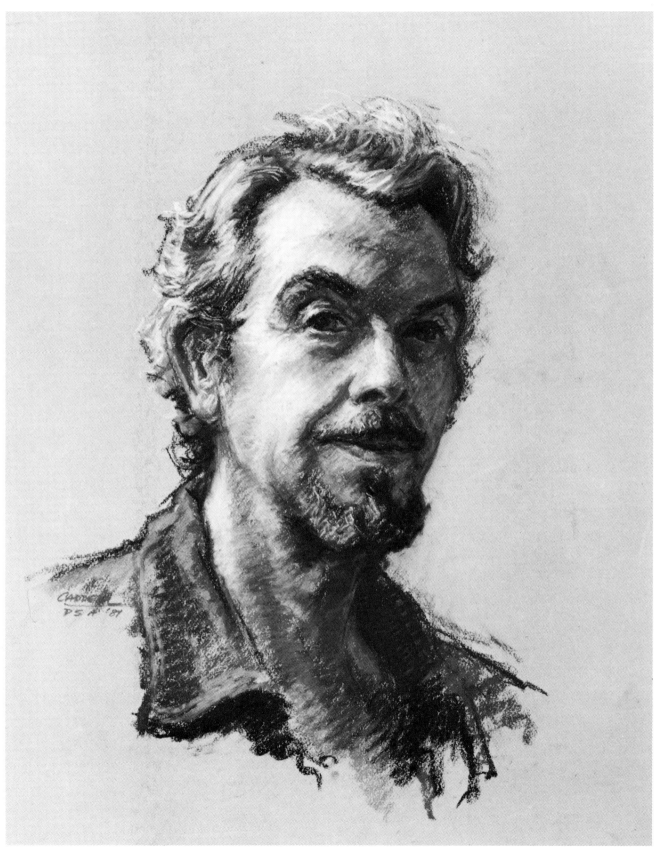

SELF-PORTRAIT AT AGE SIXTY, *pastel on paper, 20″ x 16″ (51 x 41 cm), Collection of Mrs. Foster Caddell.*

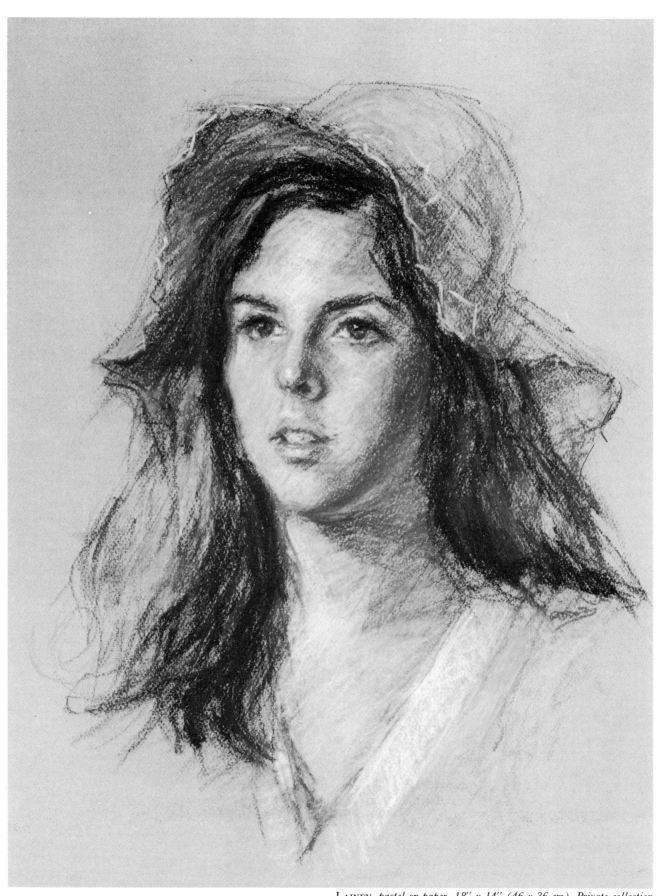

LAINEY, *pastel on paper, 18" x 14" (46 x 36 cm), Private collection.*

GALLERY

In this section of the book, I am going to change the format and, just as though the portraits on these pages were hanging in a gallery, take you on a personally escorted "tour" of them. The unfortunate part of writing a book is that space is limited, for in many instances I would have preferred to talk to you about a particular work at greater length. With this in mind, then, try to practice what I have been encouraging you to do throughout this book: learn to study and "read" a painting, be it yours or someone else's. Try to see how I have employed many of the principles discussed in the Keys. As I describe each painting, I shall explain some of the

thinking that went into it and shall try to comment on any problems that I feel are relevant to this or similar projects. I trust my experiences will add to your knowledge and help you to think out your own problems, for ultimately, that is what you are going to have to do for yourself. Someday you may be standing in front of a painting that is not going as well as you like. Only the knowledge you have been able to accumulate is going to help you realize a successful painting. This is why I am trying so hard to pass on all the information I can. If this gallery section helps you also, the many months I have devoted to this book will have been justified.

Mr. Phillips D. Booth, *oil on canvas, 20" x 16" (51 x 41 cm), Collection of the Providence Art Club, Rhode Island.*

The Providence, Rhode Island Art Club has a tradition of commissioning a portrait of each of its presidents, and I have had the pleasure of doing both this painting of Mr. Booth and the portrait on the opposite page under that program. I have known this gentleman for years. He was responsible for my securing my first job, in the art department of the Providence Lithograph Co., more years ago than I care to remember. This experience was great training for me, and it gave me a practical knowledge of the printing and publishing fields. The little pin in Mr. Booth's lapel says, to those who can "read" it, that he was head of the Narragansett Council of Boy Scouts for a number of years. It was a privilege to record for posterity a man who has been so kind and helpful to me and to others over the years.

I have often thought that the better I know a person, the harder it is to paint the individual. It is not a technical problem of putting paint on canvas, but one of interpretation. (I have heard it said that many times doctors find it hard to be objective in treating someone they know very well.)

I think you can see here some of the points I have stressed in the Keys. The head is solidly modeled, the hairline is soft, the forehead is round, and the nose seems to protrude from the face. The glasses look as though they fit on the face.

116

MR. W. CHESLEY WORTHINGTON, *oil on canvas, 20″ x 16″ (51 x 41 cm), Collection of the Providence Art Club, Rhode Island.*

What a fine, strong face this man has. It reflects his scholarly mind, for he had been associated with Brown University for many years and had traveled extensively. It was a pleasure to talk to him as I worked. He was the sort of subject I'd have enjoyed painting even if this wasn't a commissioned portrait.

I spent a great deal of time modeling his head, for the first requirement of a good portrait is a solid head that exists in space. Notice the convincingly round forehead, the feeling that the nose protrudes from the face, and how solid the chin appears. I concentrate on all these before the painting actually becomes the particular person, as I showed you in my demonstrations. In modeling the head,

the halftones in the transitional area between the lights and darks are of the utmost importance. Each subtle color and value change is critical.

The definition of the features is also very significant. I have worked for years to perfect a degree of refinement that still shows the application of the paint and is not tight. Notice how soft the edges are, creating the illusion of roundness. In close-ups like this, you can study the way I handle the paint.

These two portraits, hanging on the Art Club walls, have resulted in many other portrait commissions. They illustrate an important point to remember when displaying your work—show only your best.

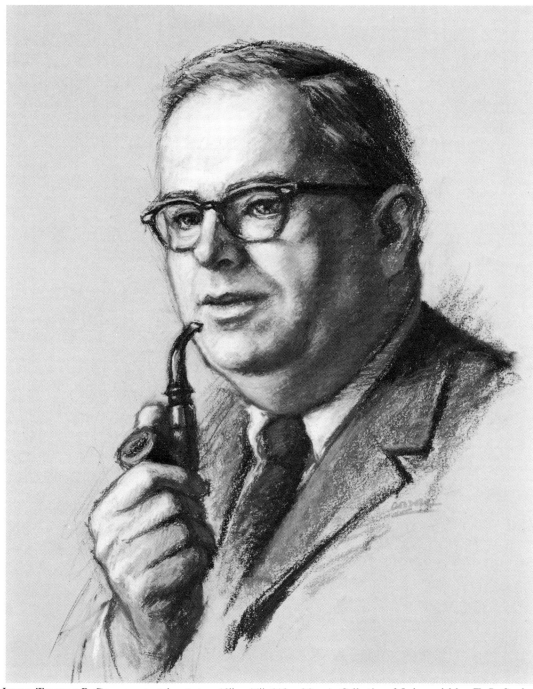

JUDGE THOMAS P. CONDON, *pastel on paper, 18" x 14" (46 x 36 cm), Collection of Judge and Mrs. T. P. Condon.*

This pastel is another example of my feeling that there is something friendly and easygoing about a pipe smoker. I felt that posing this individual holding his pipe would help to explain his personality. In this study, you can see that I used the standard method of illuminating the front planes of the face, leaving the side in shadow. This helped me to give a good solid construction to the head as a whole. The difficult passages in modeling the head were the halftones in the transitional areas between the lights and the shadows. These help create the soft curvature of the forehead and cheek areas. Notice how the shadow is

darker where it begins, and then it gets lighter where we find subtle reflected light in it. The ear, which is at a different angle, catches a little more light and becomes slightly lighter—but not too light.

See how soft the hairline is and how the glasses really fit on the face and over and around the nose. The hand is solidly constructed, but again, it is not developed as conclusively as the face. Observe the way I have handled the pastel in different areas—the face is rather refined; the hand and the pipe are somewhat less refined; and the suit is indicated rather casually. Notice traces of my original light construction lines, which I seldom bother to erase.

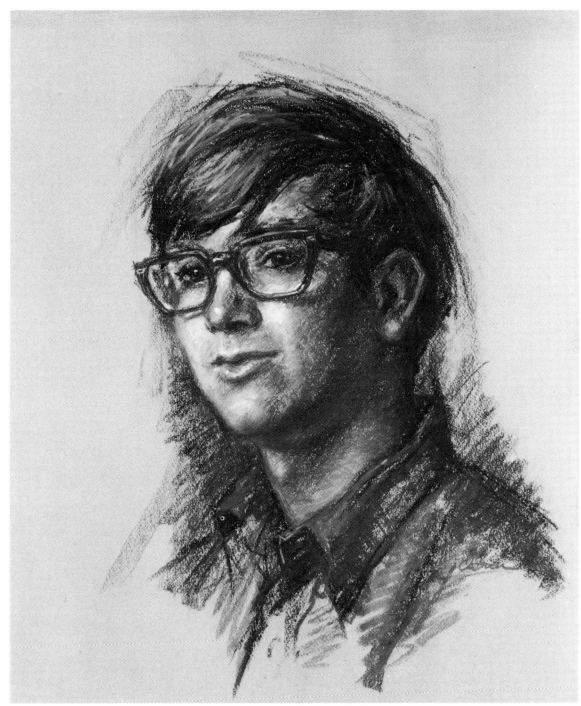

Tod, *pastel on paper, 18" x 14" (46 x 36 cm), Collection of Mr. Leonard Hutchins.*

This pastel is a study of a young student of mine. Notice that it has been treated a bit more freely as a whole than the pastel opposite. I shall relate an interesting story about the eyeglasses in this painting.

A person who normally wears glasses often looks unlike himself without them. This portrait was commissioned by the boy's parents, who felt he should have something to say about how he was to be recorded—especially since he was an art student. Often young people are self-conscious about wearing glasses, and so it was left up to him to decide whether or not he should be depicted wearing them.

As a student, the boy was naturally interested in the progress of the pastel, which I carried quite far without the glasses. Before it was completed, however, he felt he just didn't look right without them—and so, although this is not my normal procedure, I added them at that time.

The boy wore a red shirt that afforded wonderful reflected lights under his chin and in the lower jaw area. See how sensitively modeled the lips are (they are not just drawn on), and how the nose protrudes from the rest of the face.

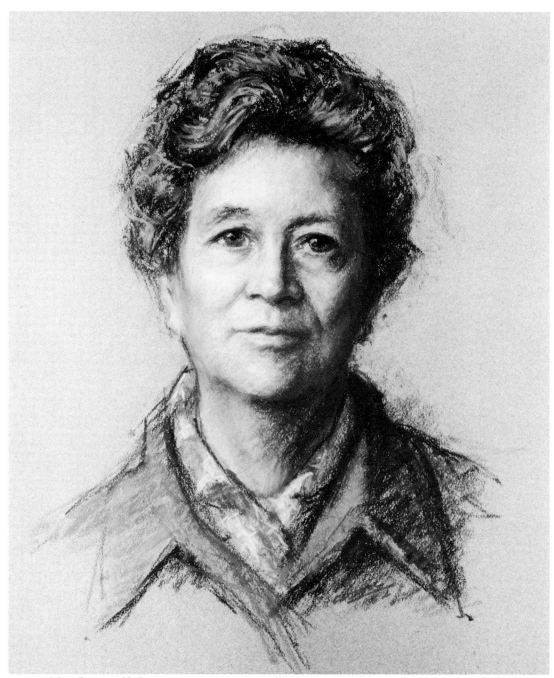

MRS. ROBERT H. IGLEHART, *pastel on paper, 18" x 14" (46 x 36 cm), Collection of Mr. and Mrs. Iglehart.*

To repeat a thought I've expressed before, one of the advantages of being a portrait painter is having a chance to meet interesting people. This gracious lady is the wife of the headmaster of a private school, and their careers in education had taken them to Africa for many years. Both she and her husband are a striking couple—quite tall, and with a rather regal bearing—yet they are warm and friendly.

The woman's frank openness and matter-of-factness, I felt, necessitated this head-on pose in which she is looking directly into the eyes of the viewer. She had good, strong features, which I modeled very softly. I kept the shadow area on the right side of the face, where it rounds the cheek and temple and recedes back to the hair. Note that the definition of the ear on this side is almost lost in shadow.

The woman's jacket and scarf indicated that she was a dignified "country tweed" type, and that is how I depicted her. Later on, however, when my wife and I were invited to her home, I saw a more casually dressed woman with a completely different hairdo. I could not help asking myself whether I had interpreted her correctly in the portrait. All I could answer was that I had portrayed her as I had seen her when she came to my studio to sit for her portrait. This is all any artist could have done under the circumstances.

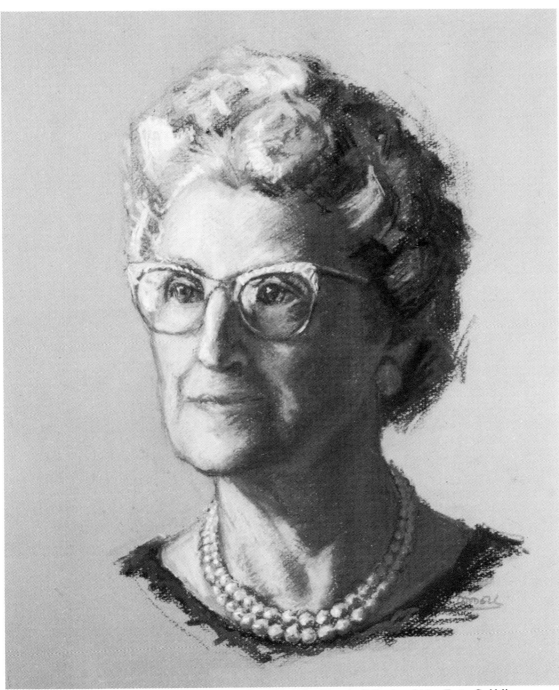

MRS. WILLIAM H. KAUFMANN, *pastel on paper, 16″ x 12″ (41 x 30 cm), Collection of Mrs. Foster Caddell.*

This lovely lady was my mother-in-law. Because she was always interested in my art career, she would have been very proud to be included in this book; but unfortunately, she did not live to see even my first book.

This portrait was done many years ago, and if I were to do it today, I probably would interpret her differently. There was a serious side to her, but she also had a sparkling, animated personality. In those days, however, I was not artistically mature enough to incorporate this into her portrait. This had nothing to do with technical proficiency, which must exist before an artist can ever hope to delve into the interpretation of personality.

I want to call your attention to some of the technical aspects of this portrait. Notice how dark the shadow side of the silvery white hair is. Also notice how well the eyeglasses fit on the face; in addition, the reflections of the studio window give a convincing appearance to the lenses. Even though glasses seldom enhance a person's appearance, my mother-in-law had to wear them constantly because she had weak eyes and it would have been a mistake to portray her without them. The simple neckline of the dress and the double strand of pearls, which I took care not to overwork, give this lady an elegant bearing even though not very much of her body shows.

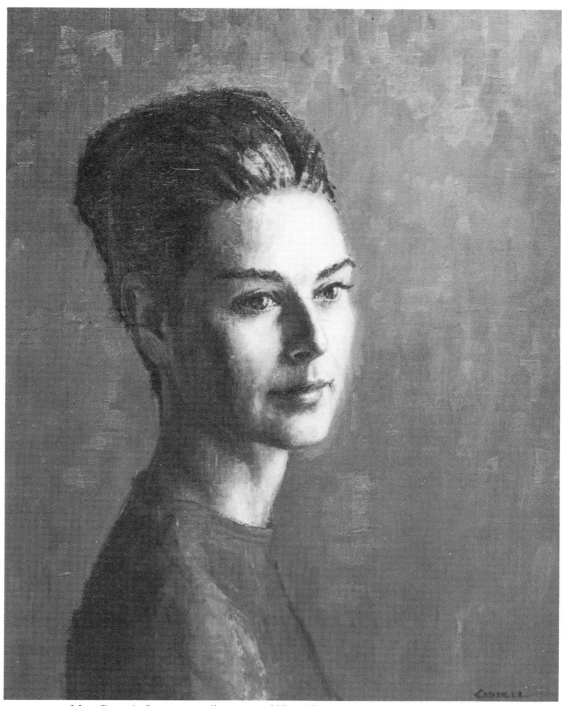

MRS. GLEN A. SCHRICKER, *oil on canvas, 20″ x 16″ (51 x 41 cm), Collection of Mr. and Mrs. Schricker.*

This woman had the unusual forethought to have her portrait painted while she was still a young lady. At the time, she was considering marriage and all that having a family entails. She said she wanted her children to be able to look back someday and see that she too was once a lovely young girl.

I was intrigued by the graceful line of her neck and body that was accentuated by the way her hair was piled up on top of her head. The pose reminded me of the famous statue of Nefertiti.

I used a standard lighting, illuminating the front of the face and leaving the side in shadow. Notice the continuity of the shadows, and the fact that I asked the model to twist her head slightly so that it would not be at the same angle as the body. She had lovely, strong Italian features, and she was the type of subject I would have enjoyed painting even if I hadn't gotten paid for it. Being an artist herself (she was doing fashion illustration at the time), she could appreciate the value of putting her money into a work of art. She has been able to enjoy it for many years, and the painting has been increasing in value.

122

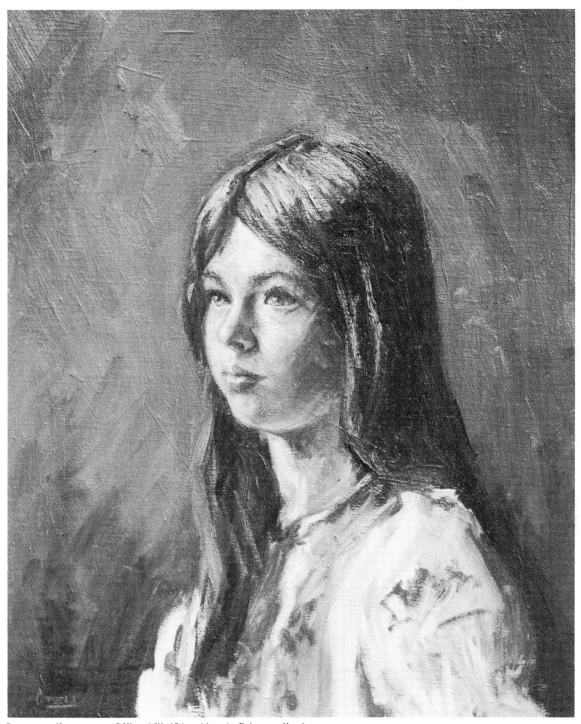

SANDRA, *oil on canvas, 20" x 16" (51 x 41 cm), Private collection.*

This girl was painted at the insistence of her mother, who was a student of mine. The mother was much more enthusiastic about the project than her daughter was, and in spite of my every effort, I'm afraid the girl's reluctance shows a bit in my portrayal. Her features were soft and round, and the play of reflected light from the blouse gave interesting color and luminosity to the shadow side of her face. Here, I handled the girl's long hair in a manner that I've mentioned before; I draped one side over the shoulder for a less symmetrical solution to its design. This also ex-

posed more of the interesting peasant blouse that she wore. I know her mother would have liked me to show much more of the intricate hand work on it, but, as I have stated in the Keys, I usually subordinate the garment to the face. Because the background is basically lighter than the darks but darker than the lights, the youngster's head seems solid and exists well in space. You will notice that I never refine my work to the point where it is slick and the viewer cannot see the brushwork.

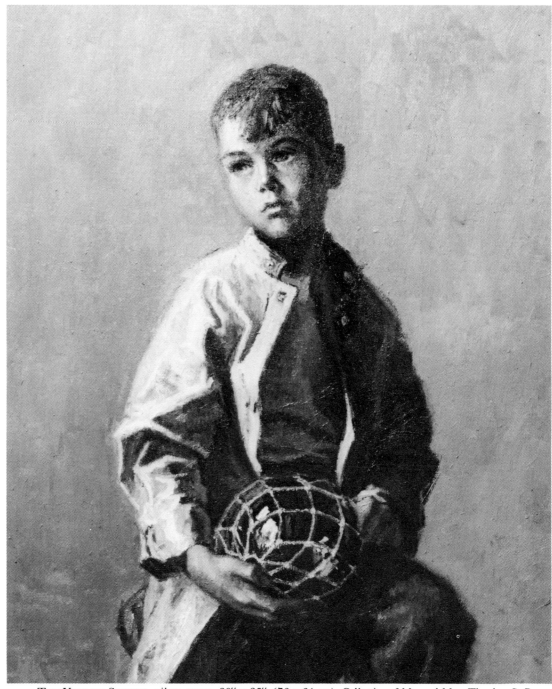

THE YELLOW SLICKER, *oil on canvas, 30" x 25" (76 x 64 cm), Collection of Mr. and Mrs. Theodore S. Daren.*

There are many paintings all around us, just waiting to be made—if we can but see them. My caveat is, of course, to train yourself to be a good enough technician so that when you decide on a theme or a subject, you will be capable of coping with it. Many amateurs spend too much time being concerned with *what* to do, when they should be learning *how* to do it.

Some years ago my wife spotted this youngster in his yellow slicker and convinced me to paint him. In those days I was working as a book illustrator, and I could only paint for myself when time permitted.

The slicker suggested a nautical theme, and so I posed the boy holding an old glass fishing float, the kind that was prevalent years ago before it was replaced by the plastic detergent bottle. The studio window was reflected on the glass, and it cast a beautiful yellow-green light across the boy's blue denim pants. He wore a white T-shirt, but it was in shadow—notice how dark it is—and this made the slicker appear to be brilliantly illuminated. This brilliance is enhanced by the fact that the slicker becomes darker than the background on the shadow side.) When it was exhibited, this painting was very popular; people seemed to relate to it.

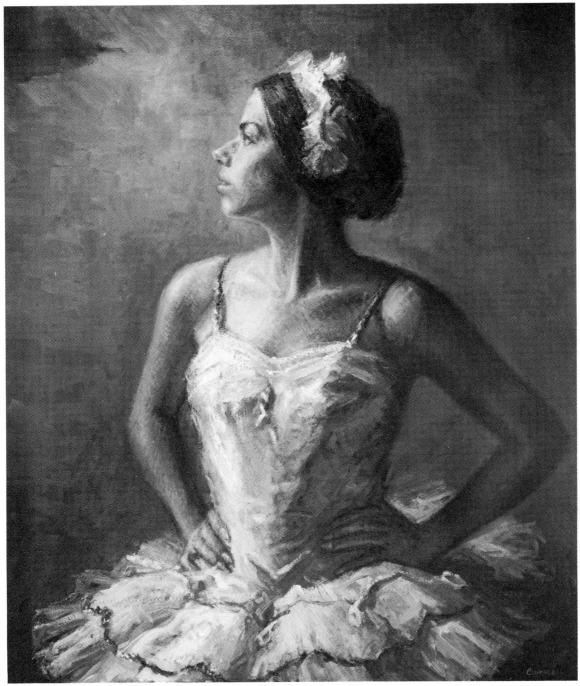

YOUNG BALLERINA, *oil on canvas, 36" x 30" (91 x 76 cm), Private collection.*

This is another painting I did for the sheer pleasure of painting, without thinking of what sells well, or having to satisfy a commissioning client. This young student of mine was always willing to pose, and you will find other interpretations of her in this book. In the pastel portrait in Key 1, she's shown with her hair down. She is also the aloof horsewoman in key 24.

In this study, the entire figure is important, not just the face. I often like to use dramatic side lighting; notice how the figure registers here as either lighter than the background (on the left side V or darker than the background (on the shadow side). I dealt with many different textures in this painting: the flesh, the hair, the feathered hair piece, and the variations within the tutu. Because many bones and tendons show more prominently on a ballerina, it was interesting to model the neck and shoulder areas. Little details such as the shadows cast on the body by the shoulder straps help convey a tremendous sense of form and solidity. Notice that although the rendering is more refined in some places than in others, you are always aware of the brushwork. It is never slick and photographic, even when I am painting the smooth, unwrinkled skin of a young person.

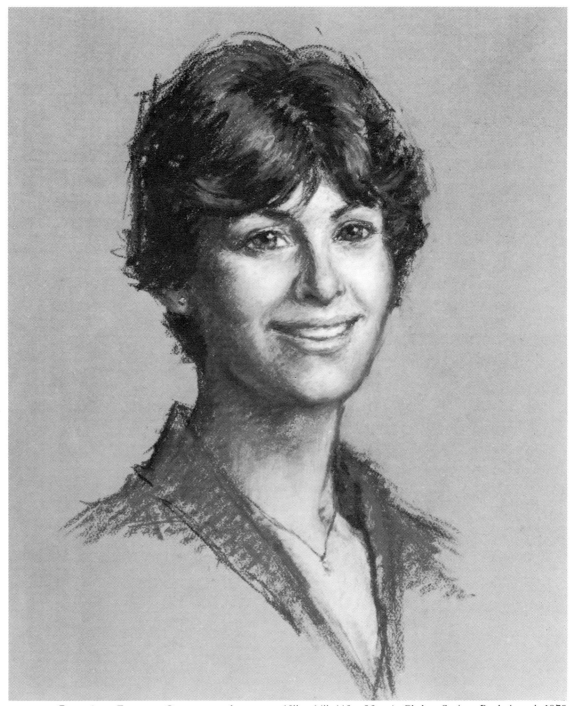

BASIA DZIENKONSKI, ROSE ARTS FESTIVAL QUEEN, *pastel on paper, 18″ x 14″ (46 x 36 cm), Chelsea Savings Bank Award, 1979.*

The nearby city of Norwich, Connecticut, known as the Rose of New England, has a Rose Arts Festival each summer. For a number of years, the Chelsea Bank of that city has commissioned me to do a pastel portrait of the young lady chosen to reign as the Festival Queen. In recent years businesses and institutions have been stepping into the role of patron, a position held by royalty and the wealthy in former times. The bank presents the portrait to the queen, and her only obligation is to loan it back to the bank each year for a collective exhibition of portraits of the past queens. With this in mind, I have tried to use a variety of poses, so that when the paintings are exhibited they do not look as though I have chosen the same solution to the project each year. Because of the vivaciousness of youth, many times I feel these portraits ought to show the subjects smiling. As I have said before, painting a smiling face is not an easy task, for it is difficult for the model to hold such an expression for any length of time.

Notice particularly that the teeth lack definition here. They are just suggested, for the last thing an artist wants is for a portrait to look like a commercial toothpaste ad.

126

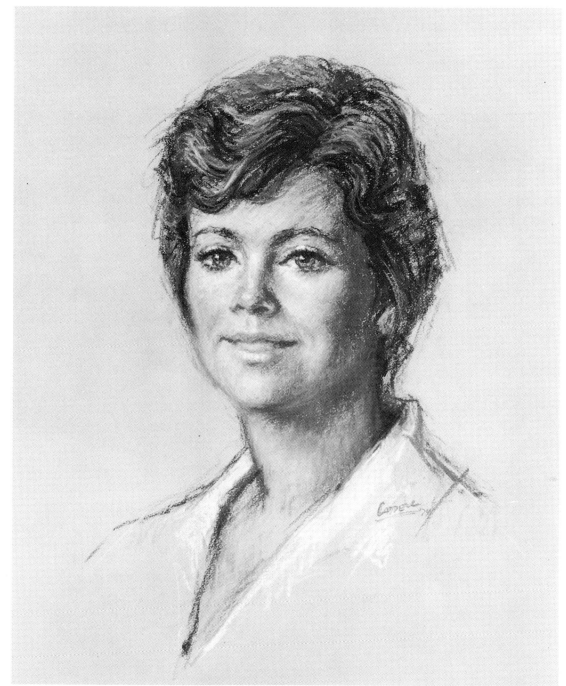

SHARON FOWLER GAGLIARDUCCI, ROSE ARTS FESTIVAL QUEEN, *pastel on paper, 18" x 14" (46 x 36 cm), Chelsea Savings Bank Award, 1974.*

There is something special taking place in both this portrait and the one opposite, and I wonder if you have noticed it! Even though the poses in both paintings are different, in each one the model is looking directly at you. I'd like to tell you an interesting story about this phenomenon. A few years ago, when I was with a group being conducted through a museum in Italy, the guide asked the group to stand in various parts of the gallery and observe how the eyes in a particular portrait seemed to be looking at us no matter where we stood. He implied that this was practically a magical power of the artist, and I felt that most of the group believed him. (The guide seemed to re-

sent my telling him later, in private, that this is a rather simple achievement.)

If the model looks directly at the artist and he paints the eyes in that position, you have the illusion that the subject is looking directly at you regardless of the angle from which you view the work. If you haven't been aware of this, try it with the paintings on these two pages. Both of these poses are standard three-quarter views, with the front of the face illuminated and one side receding in shadow. This approach is one simple way of achieving a good, solid modeling.

FIGURE STUDY, *oil on canvas, 30" x 25" (76 x 64 cm), Collection of the artist.*

This is the same model who posed for the painting in Key 28. She was a wonderful woman who personified the rugged spirit that built our great country. She lived in a seaport town, and I understand that after her husband died, she worked hard to bring up her family—even going lobstering with her boys. In later life, she enjoyed being an artist's model.

This portrait incorporates many of the principles that I have discussed in the Keys. The figure is solidly constructed, and a side light throws the depth of the face and figure into shadow. Notice the continuity of the shadow as it flows over the flesh and the dress. As usual, the background is a middle value against which both the lights and the darks register, contributing to the solidity of the figure. See how even the model's white hair is darker than the background on the shadow side. I particularly enjoyed working on her hands and arms, which bespoke the honest, rugged life she had led. The right hand is almost lost in shadow, with just a soft light over the knuckles. The other arm is really a study in various cylinders—a reminder that if you have spent enough time studying basic still life forms, you also should be able to paint a wonderful model like this.

MRS. ALBERT G. GOSSELIN, *pastel on paper,* 26" x 20" *(66 x 51 cm), Collection of Dr. and Mrs. A. G. Gosselin.*

It is always interesting to do more than just the face in a pastel portrait. This lady is a close personal friend, and although I experimented with several ideas for seated poses, I felt the standing pose you see here, with arms folded, was typical of her. I have mentioned that I think the better you know someone, the harder it is to interpret the person, but sometimes there is an advantage to knowing your subject well, as in this case.

I felt this pose expressed the woman's forthright and capable nature, yet I also wanted the portrait to show her more feminine side. I feel I captured both these qualities in the soft way I handled the features.

This painting shows why tilting the model's head at an angle different from that of the body makes for a more interesting and graceful stance.

Notice the casual, sketchy lines that remain from my first, rhythmic designing of the pose. The way values have been handled contributes to the illusion of three-dimensional form. The near shoulder and hand contain the lightest lights, helping to create the illusion of depth across the body. The head not only contains the lightest lights and darkest darks, but is, naturally, carried to the greatest conclusion. The hands are given less emphasis, and the jacket is given the least of all. Even though the hands must be subordinate to the face, careful attention must always be given to designing and rendering them. Since the model is a blonde, and she was wearing a blue suit, I worked on gray paper (no. 345).

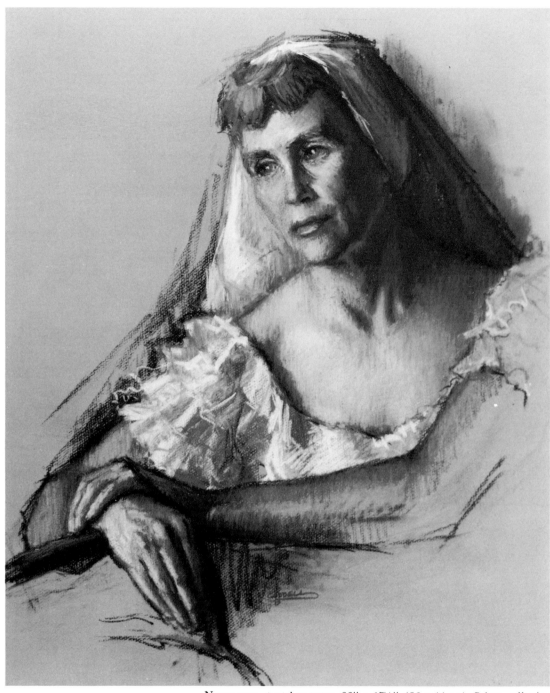

NOSTALGIA, *pastel on paper, 22″ x 17½″ (56 x 44 cm), Private collection.*

This pastel was done as a classroom demonstration. Although the model had a very interesting face with strong features, I decided on a composition that would also include her shoulders, arms, and hands resting on the handle of a market basket.

The head is solidly modeled, with the front illuminated and the side in shadow. Notice the value of the white cloth on the shadow side, where it drapes over the head.

I do not believe in rules as far as technique is concerned; this is something the individual artist develops for him or herself. However, I have always felt that a painting can become slick and contrived when the strokes of pigment, whether pastel or oil, are applied in the same direction as the contours of the object. (I discussed this with you in the Keys.) To avoid this, I quite often find myself applying the pastel in vertical strokes, as you can see here in the chest and arms. This choice is a personal idiosyncrasy, and I merely point it out to you. See how much of the arm is left suggested and how the values on the hands are much lighter than those on the arm behind them, conveying the illusion of depth. In this study I have tried to create a feeling of old-world charm, which I think suits this model well.

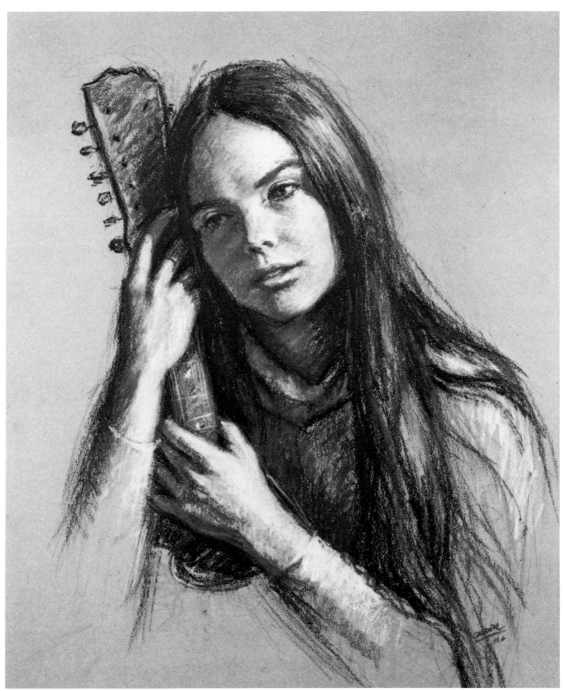

THE INNER SONG, *pastel on paper, 20″ x 16″ (51 x 41 cm), Collection of the artist.*

This is another pastel in which I tried to capture not so much the particular individual, but a mood. (I painted this same model in the oil demonstration on page 20 and in Key 3.) For a little more drama, I used side lighting, which cast half the face in shadow. I modeled her face carefully, using details such as the shadow cast by her hair on the right side of her face to give a feeling of form. Because the neck is in the shadow cast by the hair, the face comes forward. Also notice how convincingly round the forehead is, and how I selectively designed the hair so that a portion of it flows over one shoulder. Each time the model poses, watch for variations that occur in the design of the hair and the folds of the clothing—and use the best of these in your paintings.

The play of light on the model's hands enabled me to model good, solid form here. The mandolin is very casually suggested, but there is enough there to make a sufficient statement. Although rendered sketchily, the keys are all positioned at different angles, which is just what happens when the instrument is tuned.

Even though these portraits are not shown in color, study the values carefully. Next to drawing, values are the most important aspect of a work of art.

JOHN, *pastel on paper, 16″ x 12″ (41 x 30 cm), Collection of Mr. and Mrs. John C. Lucey.*

In this book, I have tried to show a cross section of the many different types of personalities I have portrayed. I would be remiss in not commenting on the subject of painting young children. They are fascinating, but they are very hard to paint because of their inability to hold still long enough for the artist to study them. Even the best of children are easily bored or distracted, and it is difficult to hold their attention for any length of time. This is only because they are children and are not mature enough to realize that even though posing is tiresome, the model's cooperation helps the artist do a better job. I'm afraid that at times an artist must have more patience than artistic talent. Pastel is particularly well suited to children's portraits because of its free, sketchy nature, but even when I do an oil painting, I handle my paint in a soft, impressionistic way.

Children have fascinated artists over the ages, but many of the early painters failed to capture their childlike characteristics and made them look like little old men and women. Equally undesirable is the type of artwork you see in many sidewalk art shows, where the pictures seem to have been ground out with clichéed solutions. Real children have different personalities, and that is what the artist must try to capture in painting them.

TARA, *pastel on paper, 16" x 12" (41 x 30 cm), Collection of Mr. and Mrs. John C. Lucey.*

The pastels on these two pages are of a brother and sister. I chose poses that would complement each other so that the portraits could be hung together as a pair. When an artist is commissioned to do a pair of portraits, the question often arises as to whether the individuals should be portrayed separately or in the same painting. There are merits to both approaches, but I do point out to parents that in later years, both children may want to hang their portraits in their own homes; separate paintings would eliminate the problem of trying to decide who hangs a composite portrait and for how long.

The poses shown here are rather standard: the front portion of each face is illuminated, and the modeling is achieved where the sides go into shadow. There are many versions of the three-quarter view. In these, the faces are turned so far that they are shown almost in profile. In each, the farthest eye is placed convincingly behind the nose. Speaking of noses, have you ever observed that, as a rule, the nose and ears continue to grow throughout a person's lifetime? Children's noses are usually small, like the cute, turned-up noses of this brother and sister, whereas noses tend to become rather large in old age. Notice also how I have merely suggested the freckles on the girl's cheek, so that they would not look overdone or become too spotty.

133

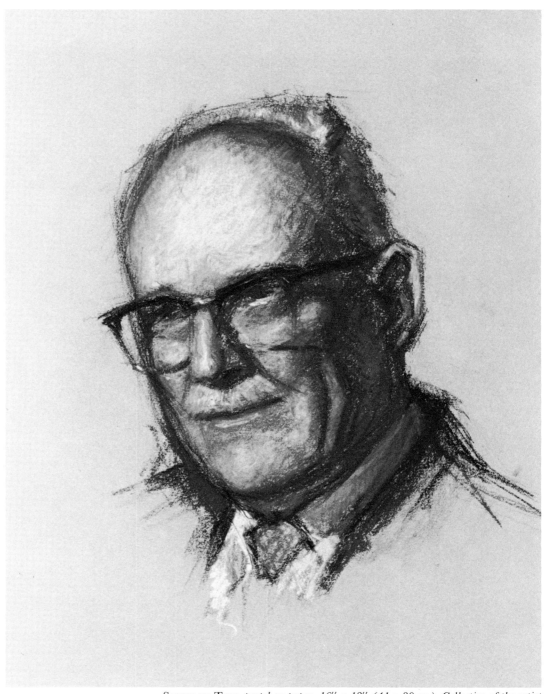

The pastels you see here and on page 135 were done as classroom demonstrations, and this might be a good time to elaborate more on the subject of demonstrations, about which I have mixed feelings. While I have no reservations about demonstrating for my own classes and workshops, I do not accept invitations to do it before art groups. My main reason is that I am no longer a fast painter, and I feel that completing a demonstration painting in one sitting would not represent my way of thinking and working. Years ago, I worked rapidly, painting a landscape in a single morning. Eventually, I learned the advantages of

slowly building a painting to a more profound conclusion, and I decided that instead of making five paintings, I would rather try to make one painting five times as good.

I have attended many demonstrations at my own art club and have seen that if the artist does not say what he has to say in a little over an hour, the audience often becomes restless and sometimes impolite. Now, some chaps can and do put on a brilliant display in a short time, but as this no longer represents my way of thinking or working, you can understand why I shy away from such demonstrations.

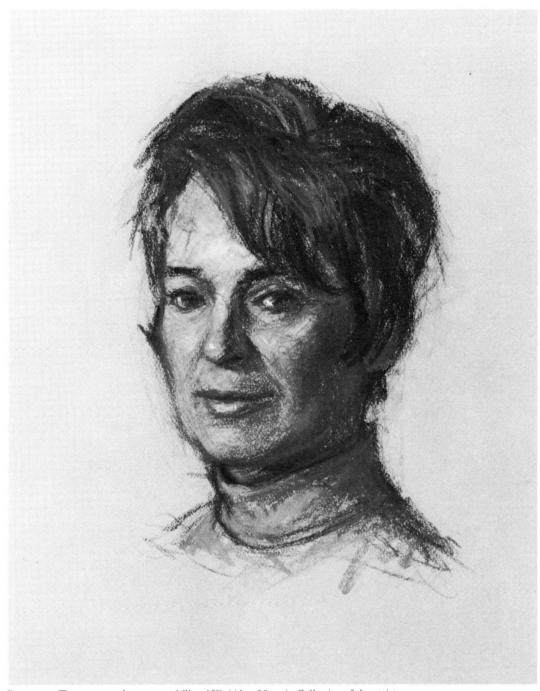

STUDY OF TERRY, *pastel on paper, 16″ x 12″ (41 x 30 cm), Collection of the artist.*

The only thing these two demonstration paintings lack, for want of sufficient time, is the refinement of detail that I usually add in the final stages to bring the work to a more complete conclusion. Other than that, each is a good, solid conception of the particular individual.

A point I would like to make here is how unimportant the last stage of refinement really is, artistically. Most of the time, students are overly concerned with this aspect much too soon in their work. A much more important principle in painting is the big overall design. To illustrate this, I often point out to my students that if any one of them stood behind a white sheet with a light behind him, casting his silhouette, he could be easily identified without any other detail at all. Why? Because of the shape and design an individual makes. This is very important to remember when you are trying to capture a person on canvas. Don't worry about whether or not the person has brown eyes, but about how the head sits on the body. Does the person have erect posture? Is the total shape heavy or slight? These are the things a caricaturist looks for and exploits. They are also the big things you must think about long before you starting dotting all the *i*'s and crossing the *t*'s with finishing details.

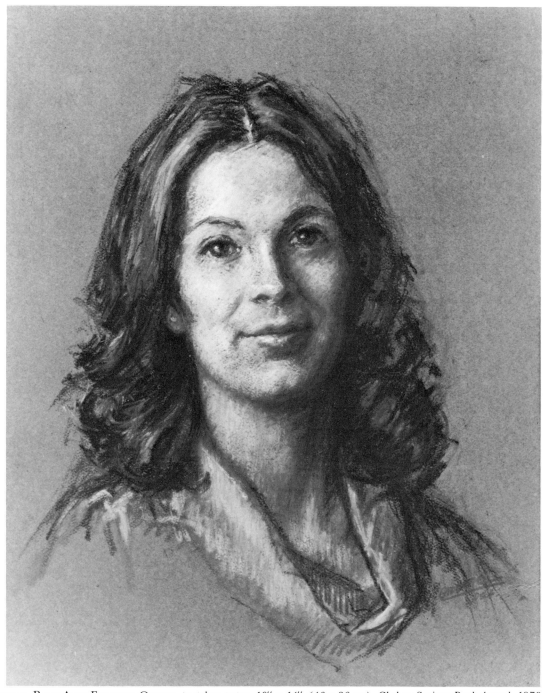

DONNA BELISLE, ROSE ARTS FESTIVAL QUEEN, *pastel on paper, 18″ x 14″ (46 x 36 cm), Chelsea Savings Bank Award, 1978.*

The two young women on these pages were chosen to be queen of the annual Norwich, Connecticut, Rose Arts Festival. Since the portraits of all the past queens are exhibited together each year, I do each one in a different pose so that the poses will not be monotonously repetitious and will make a good group exhibition. Although all Festival Queens are winners of the same competition, each is a different and distinct personality, and that's what the artist should try to capture.

I did this Festival Queen almost directly head on. She had dark hair and wore a blue blouse, and so I used a gray

paper. Smiling mouths do not have to always be open and showing teeth. Often, a slight smile, such as we see here, is sufficient. Even this subtly pleasant expression is not natural to hold over a prolonged period of time, for the corners of the mouth tend to relax downward in repose. To achieve this much of a smile requires engaging the model in conversation to animate her expression. I illuminated this model's face at a three-quarter angle, creating subtle shadows to model the right side of her face. She had lovely dark eyes, which matched her dark hair. Notice the different degrees of refinement in various portions of this pastel portrait.

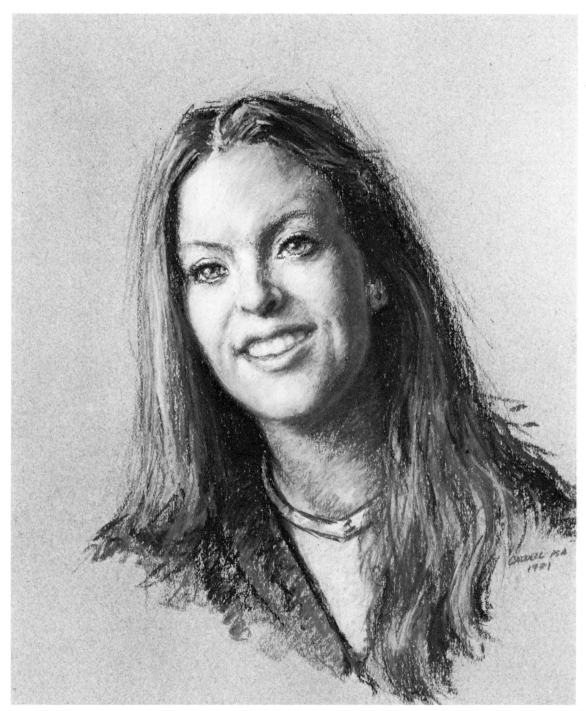

JANE McCAFFERY, ROSE ARTS FESTIVAL QUEEN, *pastel on paper, 18'' x 14'' (46 x 36 cm), Chelsea Savings Bank Award, 1980.*

For a whole year I devoted my efforts to writing this book, and all other work had to be set aside. This was the only new portrait I did during that period, and I took the time to do it only because of my annual commitment to the bank that commissions these Festival Queen portraits.

A big, wide smile was so much a part of this young woman's personality that I just had to depict her that way. I have discussed smiling mouths with you before, but here I would like to relate a true story.

I have a student who is a dentist in Virginia—he has attended my summer workshops. He has been attempting to paint portraits on his own and, perhaps because of his profession, he is bedeviled by his inability to depict a smiling mouth showing the teeth! I told him that if anyone should have an understanding of mouths, it should be he. In reply, he drawled, "If mouths were as hard to work on as they are to paint, I doubt if there would be more than a dozen good dentists in the country." I enjoyed his humorous response, but I assured him that like any other subject we don't know much about and are not sufficiently trained for, portraiture seems much more difficult in the beginning than it does later on.

CONCLUSION

The Keys I have discussed in this book are based on my having seen the same mistakes made over and over again by hundreds of students. I hope that by going over them, I will have helped you avoid them in your own work.

As I often tell my students, someday you may be standing in front of your own work and realize that things are not going well. With no teacher by your side to tell you what is wrong, you will have to rely on whatever knowledge you have been able to acquire. *You* must be able to put your finger on your mistakes and get yourself out of them. The minute you are able to define *why* a mistake has been made and what is wrong, you have the keys to helping yourself. Remember, there are only three categories in which the mistakes can take place: drawing, values, and color.

I originally thought of giving my books a series title—"Teaching You to Be Your Own Teacher"—for that is what the Keys are intended to do, and I have tried my best to give you the knowledge you need. I hope you have learned a great deal from these Keys, for I know many amateurs have never had anyone take the time to explain some of the principles I have tried to cover.

Personal Style. One issue that students bring up time and time again is that of "personal style." Some schools stress this over and above the necessity of learning the craft of painting well. It's the "I've got to be me" syndrome. My advice to students is to stop worrying about developing a personal style in the beginning. They also need to realize that they will be influenced by their teacher's style. Do not study with a person unless you admire his work and want to paint more or less in the general manner that he does, because that is the direction in which you will be bound to go. If your teacher is *not* a definite influence on you, you have not learned anything

from him. To preserve your individuality at this point is to preserve your ignorance. It is rather like going to medical school and stating, "I'm going to operate *my* way." My advice is to find a very good teacher who inspires you, and to absorb all he can teach you.

I have studied with three strong teachers, and at each stage of my development, as I became a blotter soaking up all they had to offer me, my work in many ways resembled theirs. Later, when I left their direct influence, my work became *mine*, a combination of all their influences plus those of the great painters in history whom I had learned to admire. While on the subject of teachers, I want to offer a word of advice and caution. My art instruction with these three teachers took place over a period of almost twenty years. One of the greatest mistakes students make is hopping from teacher to teacher, hoping that the *next* one is going to give them all the answers and "secrets." The grim reality is that although many amateurs are looking for easy answers, learning to paint is a tremendous amount of hard work. Art, like most things in life, only gives you as much as you give it. Every stroke on your canvas shows how much you know and don't know. I sincerely hope that, by studying this book, you can become much more knowledgeable about the problems of painting.

There was a time when painting in a representational way was tantamount to automatic rejection from many shows—especially those judged by someone who could see merit only in modern art. It may seem hard to believe now, but when I was beginning to paint it took a great deal of courage to choose the conservative path of being a representational painter. I was out of step with the times, but even though I realized that my work would not even be considered in many exhibitions and artistic circles, I had to paint in a way that *I* believed in, for I had to be honest with my-

self. I am glad that I had the courage of my own convictions. And thank goodness, the extreme swing of the pendulum has reversed itself, and more students now want to paint in a traditional way. I have lived through such great changes as seeing Maxfield Parrish and Bouguereau being thought of as contemptible at one time, and later their becoming new-found "greats" as the pendulum of fashion swung back and forth.

Model Releases. I have tried to point out many of the pitfalls you may encounter in doing portraits, but now I want to add yet another one that is not connected with the actual painting but is nevertheless *very* important if you ever expect to reproduce your work: namely, model releases.

This book has been a labor of love and was for the most part very pleasurable, but one unpleasant incident did occur. Perhaps my sharing it with you will help you avoid the problem I had. On projects like this book, it is customary for the publisher to request, for legal reasons, that the people depicted in the portraits sign what is known as a release form. Illustrator Norman Rockwell once said that because of the nature of his work, he routinely had all his models sign releases, for which he paid them a token fee of, I believe, about $5.00. I have been aware of the existence of releases for some time, but being a trusting soul, and feeling that I had a very good relationship with each of the people I painted, I had never bothered with them until I wrote this book. With only one notable exception, the people whose portraits are reproduced in this book sent back the necessary forms not only signed, but also with handwritten notes: "Happy to be included," "Honored to be in your book," "My claim to fame," etc. The response was most gratifying. *All* the people were cooperative, save one—a man whom I had naively believed would also be very cooperative. However, he wanted a sizable sum of

RELEASE FORM

I_____,
do hereby give_____,
the artist, the irrevocable right to use my picture, portrait, or photographic reproduction of same, in conjunction with my name or a fictional name, in all forms or media, and in all manners for trade or any other lawful purposes, and I waive any right to inspect or approve the finished product, including written text that may accompany its reproduction.

I am over 21 years of age and have read this release and am fully familiar with its contents.

Date_____ _____
 (model's name)

_____ _____
 (witness) (address)

 (address)

I am the parent or guardian of the above-named model, and I approve the above release signed by the underage model, with the same force and effect as if executed by me.

 (signature of parent or guardian)

 (address)

money for signing the releases that everyone else had signed gratis.

Reluctantly, I decided that I had no choice but to eliminate his picture from the book. Legally, I could not publish his picture without the release. (If everyone else had taken his attitude, you would not be holding this book in your hands!)

I am told that incidents of this sort are most unusual, but through it I have learned the value of having the model sign a release when he or she poses.

I have checked with Artists' Equity and several other sources but can find no single standard release form. They can vary from a simple informal letter of agreement, such as I used when doing this book, to the long, complicated form used by professional photographers. You might consider using the form on page 139, which is a compromise between the two extremes.

Developing Your Painting Skills. Over and over again, I have stressed the importance of becoming a superb craftsperson if you wish to paint portraits or anything else well. Students generally want to paint certain things that interest them—portraits, landscapes, flowers, etc. But instead of focusing on specific subject matter, they should be thinking about learning to *paint*. I believe that the foundation of the craft is still life painting, and that the way to develop your ability to paint portraits is to practice painting still life subjects. They don't move, they don't take rest breaks, and the folds of fabrics stay consistent.

I keep my students painting still lifes until I feel they are ready for the more exacting subject of portraits. One of my students, a doctor, once protested when I would not let him "try the face," yet I knew he was not ready for it. Finally, to settle the situation, I said, "All right, I'll let you go into the operating room—as long as we both know right now that the patient is going to die." He promptly replied. "I get your point!"

Now, when I stress the importance of still life painting, I don't mean you should merely record the general appearance of some inanimate objects. I mean that you should approach it as a training ground for drawing well, observing value relationships, and learning to mix any color that you see. Until you have mastered still life painting, you are going to have trouble painting the human form or anything else. I occasionally have beginning students who profess to have a "feeling for faces," but when they render a still life it is drawn badly and lacks form because of inaccurate values and color. I recommend that you work on your still life arrangements as though they were portraits, and then you will have less trouble when you tackle the demands of painting people. I hope by now I have convinced you that the foundation of all painting is still life training, and I will go into this subject in depth in my next book.

INDEX